Alberto Giacometti
in Postwar Paris

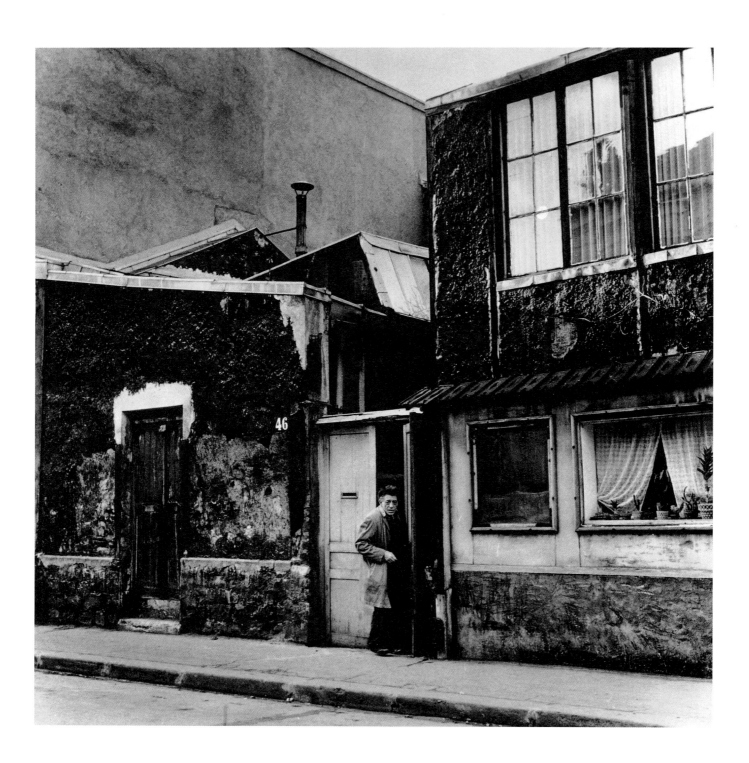

Alberto Giacometti
in Postwar Paris

Michael Peppiatt

YALE UNIVERSITY PRESS, NEW HAVEN AND LONDON
in association with The Sainsbury Centre for Visual Arts,
University of East Anglia, Norwich

Sainsbury
Centre for
Visual Arts

This catalogue accompanies the exhibition
Alberto Giacometti in Postwar Paris

Curated by Michael Peppiatt

Sainsbury Centre for Visual Arts
2 October – 9 December 2001

Fondation de l'Hermitage, Lausanne
1 February – 12 May 2002

Cover illustrations: *Standing Woman*, 1958–59. Bronze, 132.1 × 20 × 34.5 cm. Robert and Lisa Sainsbury Collection, University of East Anglia (front); Ernst Scheidegger, *Alberto Giacometti painting Annette, c.* 1960 (back). Page ii: Paul Almasy, *Giacometti in front of his studio in the rue Hippolyte-Maindron*, 1960.

Exhibition curated by Michael Peppiatt
SCVA Curator, Amanda Geitner
Exhibition design by George Sexton Associates, Washington D.C.

Designed by Beatrix McIntyre
Set in Walbaum
Printed in Italy

ISBN: 0-300-09242-3 cloth
 0-300-09069-2 paper

Library of Congress Control Number 2001093115
A catalogue card reference for this book is available from the British Library.

The Sainsbury Centre for Visual Arts
is supported with funds from the

Contents

LENDERS TO THE EXHIBITION

Paul Büchi Foundation, Switzerland

Pieter Coray, Switzerland

The Detroit Institute of Arts

The Fitzwilliam Museum, Cambridge

Annette Giacometti Estate, Paris

Paul and Margrit Hahnloser, Switzerland

Beda Jedlicka, Art Focus, Zürich

Kunsthaus, Zürich

Louisiana Museum of Modern Art, Humlebaek, Denmark

Fondation Marguerite et Aimé Maeght, Saint-Paul

Paule and Adrien Maeght Collection, Paris

Jean-Yves Mock, London

Centre Pompidou, Musée National d'Art Moderne, Paris

The Robert and Lisa Sainsbury Collection,
University of East Anglia, Norwich

The Smithsonian Institution.
Hirshhorn Museum and Sculpture Garden, Washington DC

Michel Soskine, Paris

Thérèse Berthoud Tigretti, Geneva

The Tate Gallery, London

Swiss Foundation for Photography, Zürich

FOREWORD

It is particularly fitting that the Sainsbury Centre should be the location for the United Kingdom's most comprehensive celebration of the work of Alberto Giacometti in this, the centenary of his birth. Robert and Lisa Sainsbury first met Giacometti in Paris in 1949 and from that meeting developed a warm friendship which was based on a shared appreciation of remarkable objects and, on the Sainsburys' part, a discerning admiration for Giacometti's creativity. Many of those works which today form part of the Robert and Lisa Sainsbury Collection were acquired during the 1950s, including the very personal portraits of two of their children, but the Sainsburys continued to add pieces even after Giacometti's death in 1966, so that today the Collection houses a wonderful corpus of works from the artist's postwar period.

We are immensely grateful to Michael Peppiatt, who has acted as guest curator for this centenary exhibition, which, in a slightly different form, will travel early in 2002 to Lausanne, taking this survey of Giacometti's work 'home' to Switzerland. This is the third special exhibition of Giacometti's work to be mounted in the Sainsbury Centre: *Alberto Giacometti* was curated in 1984 by Graham Beal, and the late David Sylvester curated *Trapping Appearance* in 1996.

Many individuals and institutions have lent generously to this exhibition and to them we are both warmly grateful and heavily indebted. Pro Helvetia, Arts Council of Switzerland, has generously contributed towards the production costs of this catalogue, which has been the result of an enjoyable collaboration with Yale University Press.

Our most enduring gratitude, as always, is to the late Sir Robert and to Lady Sainsbury. Without their perceptive and inspirational vision as collectors, as patrons and as benefactors, there would be neither intellectual nor physical context for this exhibition.

Nichola Johnson
Director, Sainsbury Centre for Visual Arts

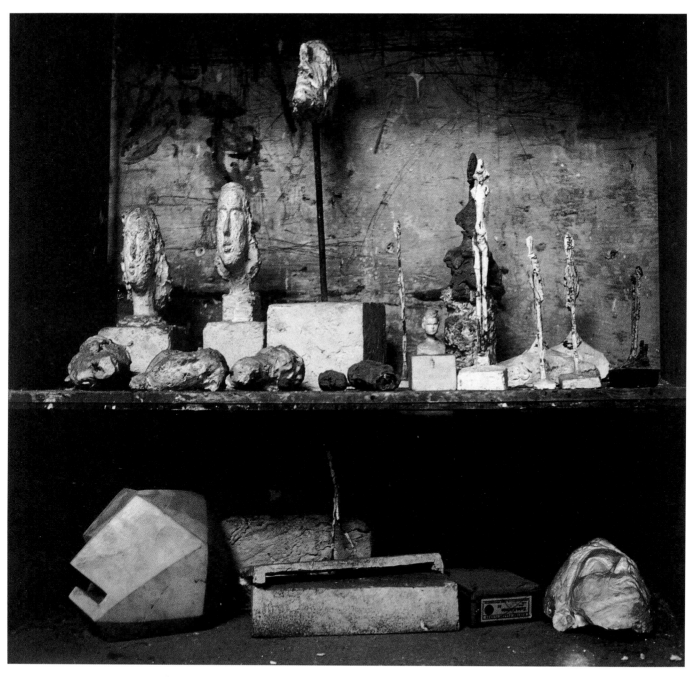

Ernst Scheidegger, *In the Studio,*
Paris c. 1953.

ACKNOWLEDGEMENTS

My first and deepest thanks go to Lisa Sainsbury for having had the idea of this Giacometti exhibition and for having asked me to curate it. Without her and her late husband Robert, an exhibition of this quality would have been unimaginable. Then I should like to thank Nichola Johnson and all the staff at the Sainsbury Centre for Visual Arts, particularly Amanda Geitner, for having worked so tirelessly and so cheerfully with me through every stage of the exhibition. Several people played a key role in ensuring that we were able to bring together the works we wanted. We extend our warmest thanks to Kosme de Barañano, Thérèse Berthoud Tigretti, Pieter Coray, Hélène da Camara, Roberto Perrazone and Jean-Louis Prat. Many others have also given their precious support to the project. We are especially grateful to the following for their generous help and expertise: Anne-Marie Aeschlimann, Ida Barbarigo, Agnès de la Baumelle, Graham Beal, Alice Bellony, Simon Blakey, Jeanne Bouniort, Charles Campbell, Kate Carreno, Juliane Cosandier, Catherine Couturier, Casimiro Di Crescenzo, James T. Demetrion, Jacques Dupin, Sara Dutton, Giselle Eberhard, Patrick Elliott, Letizia Enderli, Valerie J. Fletcher, Joseph Geitner, Bruno Giacometti, Emma Hazell, Philip Herrera, Steven Hooper, Christian Klemm, Rudolf Koella, Max Kohler, Steingrim Laursen, Jeremy Lewison, Jill Lloyd, Marjorie Loggia, Olivier Lorquin, Beatrix McIntyre, Zoran Music, John Nicoll, Annette Pioud, Kay Poludniowski, Sally Radic, Gérard Regnier, David Sainsbury, Don Sale, Veronica Sekules, Nicholas Serota, George Sexton, Carl Snitcher, Rudolf Welhagen and Michel Van Zele.

Michael Peppiatt

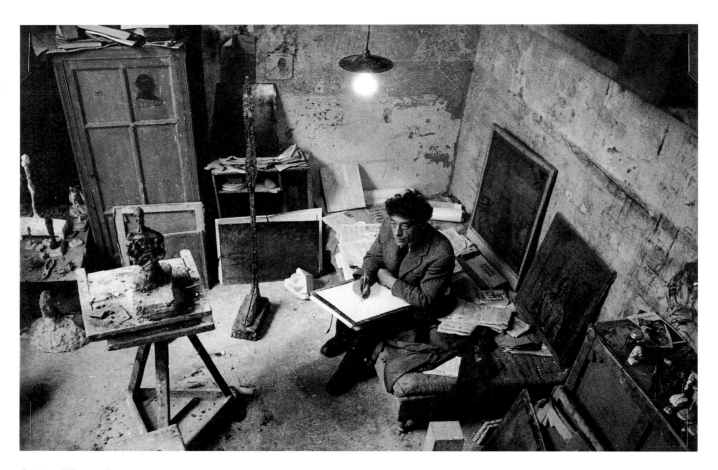

Sabine Weiss, *Giacometti drawing*, 1954.

GIACOMETTI AND THE SAINSBURYS

Michael Peppiatt

To describe the unusual relationship that Bob and Lisa Sainsbury forged with Alberto Giacometti from 1949 onwards, we have to go back to a world still reeling from the after-effects of war. Throughout Europe relief at having survived into what would be called the 'age of anxiety' was accompanied by a host of frustrations. There were shortages, rationing and a general atmosphere of austerity. Foreign travel was limited, not least by stringent currency restrictions. In the prevailing mood, pleasure was not encouraged, and conspicuous enjoyment positively frowned upon.[1]

Given those circumstances (only some fifty years ago, but already a distinct, historical past), it was hardly surprising that art collecting did not loom large. The art world, particularly the contemporary art world, was infinitely smaller and more intimate than it is today. It consisted of a handful of influential collectors and dealers drawn essentially to what was happening in Paris. New York was just emerging with all its brash vitality, and London, although it barely realized it, could lay claim to two artists, Henry Moore and Francis Bacon, who would count among the masters of the second half of 20th-century art history. But Paris, rising from the ashes of its inglorious war, would remain the traditional and undisputed centre of the arts well into the 1950s.

Bob and Lisa Sainsbury began going to Paris together shortly after their marriage in 1937. Lisa, who had been brought up in Paris and educated at the Ecole Alsacienne, was totally at home in the city. 'The rue de Seine was as natural to her,' Bob Sainsbury later put it, 'as the Charing Cross Road was to me'.[2] Once over the Channel, she proved to be an invaluable guide and interpreter. In 1938 they met the dealer Pierre Loeb, a pivotal figure in the Paris art world whose Galerie Pierre on the rue des Beaux-Arts had long been prized for the range and quality of the art it showed.[3] From Loeb the young couple bought their first pieces of Oceanic art, and shortly afterwards a small gouache by Picasso entitled 'Head of a Woman'.

Loeb fled Paris for Cuba at the beginning of the war, and the

Sainsburys were not to see him again until 1949. By that time the astute dealer's studio-like gallery was fully re-established, and it was exhibiting several works by an artist Loeb had known since the late 1920s: Alberto Giacometti. 'I'm not sure now whether we'd seen Giacometti's work before, because we'd been to Pierre's gallery so often,' Lisa Sainsbury recalls. 'But that was certainly the occasion when we started to collect it.' They came away with a painting, *Diego Seated* (1948), and a *Self Portrait* drawing (1935), for £123 and £6 respectively. However miraculous the purchase now sounds, they also came away with something even more valuable: an introduction to Giacometti himself. As the painting was unsigned, Loeb suggested to its new owners that they should visit Giacometti in his studio and ask him to sign it for them. Loeb also warned the Sainsburys that Giacometti would try to take the picture back, famously claiming that it was unfinished; and that if they allowed this to happen, they would never see their painting again.

In the event, the Sainsburys resisted Giacometti's appeals that he should 'finish' the work and instead began a friendship which was to last until the artist's death. While they were standing in Giacometti's cramped, dusty lair, they saw another drawing — of the artist's faithful brother, Diego — which they liked. Giacometti offered it to them for the same price they had paid for the *Self Portrait*: £6. This threw the young couple into something of a dilemma: they had earmarked the last £6 of their foreign currency allowance for a good dinner in Paris before returning to England the following day. The passion for art got the upper hand, however. Having bought the second drawing, the Sainsburys had a sandwich supper made more memorable than any banquet by the works they had just acquired.

Thus began what Bob Sainsbury was to describe as a 'close friendship of a very curious kind.' Since his spoken French was limited and Giacometti's English virtually non-existent, they communicated via Lisa. 'I think Bob might have tried out his French if I hadn't been there,' Lisa Sainsbury recalls. 'It inhibited him, because he thought he might make a fool of himself.' Bob Sainsbury saw the bond developing between Giacometti and himself as akin to the relationship that might grow between two deaf and dumb people, reaching out towards each other through a shared passion for the language of form. One can also see Giacometti, with his inspired trust in the unconventional, relishing this alternative mode of communication. Yet when Giacometti undertook an oil painting of Bob, the fact that two of them were alone in the studio emboldened the English sitter to attempt a conversation in French — apparently with success. This

fine portrait (see illus. p. 143), long believed to have been abandoned, has the distance and grandeur of an ancient Egyptian figure, seated for all time in regal serenity. The mutual admiration tempered by tact that existed, mostly unspoken, between the two men is subtly conveyed in the hieratic pose. And we are particularly grateful to the Annette Giacometti Estate for allowing us to show the painting for the first time in this exhibition, where it joins several other portraits of the Sainsbury family.

The bond between artist and collector was substantially strengthened in 1955 when, at Lisa's request, Giacometti agreed to make drawings of two of their children, David and Elizabeth – the former for Bob's birthday on 24 October, the latter as a present for Christmas, 1955. Nearly half a century on, David Sainsbury, now Lord Sainsbury of Turville, remembers the experience of sitting to Giacometti very clearly. 'We were coming back from the Dordogne,' he recalls, 'and my mother suddenly said to me – I was at that lanky adolescent stage, shooting up and rather slim – "you look like a Giacometti". Then she got in touch with Giacometti and I was taken over to his studio for a sitting. Of course, I didn't really know what was going on. But I was impressed by the tiny, cramped room that my parents left me in. It looked so frugal, so sparse. And Giacometti was terribly nice and very friendly. But as soon as he had settled me down and begun to draw, he became very absorbed and silent. Then he started agonizing and groaning, saying how impossible it was and rubbing his hands over his face. It was very exciting and, of course, to me at that age, rather incomprehensible. After two or three hours, my parents came back to collect me and they looked at the drawings he had done and they were delighted. I also remember, when I went back later to live for a while in Paris and saw Giacometti again, how struck I was by his desire to live without any possessions. I think his ideal was to live in a hotel room and own nothing at all.'

Executed swiftly on that afternoon in September 1955, the pencil drawings show the fifteen-year-old David Sainsbury in three distinct poses: head and shoulders, profile and full-length (see illus. p. 95–97). Knowing that he could not keep his young English model and endlessly rework the portraits may have put the artist under pressure; yet these sketches are unusually fluent, with few signs of lines erased and reworked. Over the preceding few years, Giacometti had become increasingly convinced that only by capturing a sitter's 'gaze' could he or she be brought alive in a portrait. Here the eyes, framed by

heavy spectacles, dominate the head and command one's attention, even when, as in *David – Full-Length*, the eyes themselves are virtually obscured by the way the lenses have caught the light. Giacometti often referred admiringly to the way New Hebridean sculptures captured the human gaze by totally unrealistic means. Here, not unlike Lewis Carroll's 'grin without the cat', we are confronted by a somewhat eery, eyeless gaze.

A couple of months later, in December 1955, it was Elizabeth Sainsbury's turn to sit for Giacometti in the cluttered chaos of his little studio behind Montparnasse. The four portraits that came out of this session are markedly different from those of her brother: the climate is more sombre and tormented, the erasure marks and reworkings patently visible. And in comparing both sets of drawings, one realizes to what extent they are also portraits of Giacometti: the shifts in his mood as he repeatedly flouts his spontaneous technical prowess, the constant quest for an impossible living truth glimpsed in the swirl of pencil lines, and the dejection that follows as the artist senses it slipping from his grasp.

Where David appeared above all in outline, Elizabeth emerges through heavy chiaroscuro. This was the first time in twenty years, according to Giacometti, that he had used shadows on the face; and, as a result, he was particularly unwilling to part with his first drawing of *Elizabeth – Head and Shoulders* (illus. p. 98), thinking it might be useful to be able to refer to it at a later date. In fact he made a note, intended for Lisa Sainsbury, on the second drawing in the Elizabeth series, saying somewhat plaintively: 'Your daughter would like to take another one it's quite impossible for me to give it to her now, I will give her one when I've got something better! As you can see all these drawings are failures just like the others I have done, I very much regret it but we'll have another go I hope after New Year. At the moment I am absolutely incapable of drawing. Paris 3 Dec. 1955.' This sense of frustration lasted through the sitting. On the last drawing (illus. p. 101), which shows Elizabeth with a strange beam of light slanting across her face, created by impatient erasures, Giacometti has scribbled: 'rien ne tient!' ('nothing works!').

Giacometti's insistence that his drawings were worthless was no mere coquetry. In this instance, as with many other collectors, he resolutely refused any payment for them. In the end Lisa gave Giacometti a small Egyptian sculpture, which pleased him. He in turn presented her with the delightful little bronze *Head of Rita*. But the Sainsburys did not in fact buy a sculpture by Giacometti until 1959. The reason for this, Bob Sainsbury recounted later, was

that he had not seen a sculpture that touched him deeply. Then one day, when he walked into Giacometti's studio, he was confronted by the magnificent plaster figure of *Standing Woman* and reacted immediately. 'This is it,' he said to himself, and he told Giacometti how much he would like to have it.

Characteristically, Giacometti considered that the plaster was not good enough to be cast. Pierre Loeb had also asked him to get it cast, but Giacometti refused. When Giacometti had made up his mind on a question, whether ethical or aesthetic, he did not easily alter his view. It says a great deal about his regard for his English friends and patrons that, once he felt that they were truly pleased with the plaster, Giacometti agreed to an edition of two: one for the Sainsburys, and one for himself.

The Sainsburys, for their part, did not stop at acquiring works from the artist alone. Their appreciation for Giacometti grew as the friendship deepened, and they began to build up a complete corpus of his work in all media, including prints. From Pierre Loeb the Sainsburys went on to buy two further paintings, *Diego* and *The Tree*, and many of the other drawings they chose came to them via the influential private dealer John Hewett, who played a crucial role in shaping their taste. The *Head of Isabel II* (1938–39), which once belonged to the sitter, artist and model Isabel Rawsthorne, entered the collection comparatively late, in 1974, constituting their last major acquisition of a work by Giacometti.

By that time, the Sainsbury name had become synonymous in the English art world with the individual taste, foresight and courage which make collectors great. Nowadays, looking at the number and range of the Sainsburys' Giacomettis alone, that reputation is clearly all the more assured. But it is far more impressive when one thinks back to 1949 and visualizes the young couple taking the plunge. For which other collectors in England in that dour, postwar period had recognized Giacometti as one of the greatest artists of the century?

1 I am thinking of instances such as the stern disapproval Cyril Connolly stirred up at that time when he recounted how much he had enjoyed a (relatively simple) meal in France.

2 See the excellent introduction by Graham Beal to Volume One of the *Robert and Lisa Sainsbury Collection*, edited by Steven Hooper, New Haven, London and Norwich, 1997. I am deeply indebted throughout the above essay not only to this introduction but also to the illuminating notes which Graham Beal provides in the same publication to every work by Giacometti in the Sainsbury Collection.

3 The Galerie Pierre was much favoured by the Surrealists. When Giacometti exhibited there (with Miró and Arp) in 1930, his work caught the eye of André Breton, who subsequently invited the young sculptor to join the Surrealist fold.

ALBERTO GIACOMETTI IN POSTWAR PARIS

Michael Peppiatt

Alberto Giacometti arrived at the Gare de Lyon on the overnight train from Geneva on 17 September 1945. He had been away from Paris for over three and a half years – far longer than he had intended, since he had originally gone to Switzerland to visit his mother, to whom he remained devoted throughout his life. What had kept him there was not so much the difficulty of obtaining a visa to return to occupied France but his sculpture, which had grown so small that most of the plaster figures he modelled ended up by disintegrating completely.[1]

The process had begun in 1938, when Giacometti started to sculpt from memory rather than from a living model. To his consternation, the size of his figures dwindled dramatically, as if following a will of their own, until they were no more than two inches high. Desperately eager to work on a 'normal' scale, Giacometti imagined that this was a passing phase and that his figures would eventually begin to grow again. Since he relished a challenge and enjoyed pitting his exceptional natural talent against difficulties, the artist rented a small, unheated room in a dingy hotel in Geneva and concentrated obsessively on the problem. What he was trying to recreate in sculpture was a particular image that he had glimpsed one night and which had haunted him with its mysterious intangibility ever since.

Since he had first seen her talking and laughing uproariously with her friends in a café in Montparnasse, Giacometti had been fascinated by a strikingly attractive young Englishwoman called Isabel Nicholas.[2] Isabel, a painter who had modelled for Epstein and Derain, was intrigued by Giacometti, with his large, handsome head and animated way of talking, but she was about to marry the well-known foreign correspondent Sefton Delmer and was too caught up in the pleasures of Parisian life to pay much heed to the sculptor's rather shy attentions. One night Giacometti had glimpsed Isabel standing some distance away from him on the Boulevard Saint-Michel, framed by the darker outlines of the surrounding buildings. The vision of a small, solitary figure, whom he ardently desired,

engulfed by darkness and as if unobtainable, made a lasting impression on him. To convey the full spatial force of the vision, Giacometti realized that he would have to make a small figure set high on a large pedestal. But only by finding the exact proportions, however exaggerated, between figure and base would he be able to evoke the seemingly immense and overawing distances that lay between him and Isabel.

After endless attempts in his cramped Geneva bedroom, Giacometti still felt he had not achieved his goal to recreate Isabel as he had seen her. Rather than grow larger, the figures he tirelessly kneaded grew smaller and smaller until a last touch of thumb or penknife made them crumble into tiny heaps of lifeless plaster. Of those that survived, many were deliberately destroyed by Giacometti as failures, so that when he finally decided to return to Paris he was able to fit his entire production of the previous three years into six matchboxes, which he carefully secreted in his pockets for the journey.

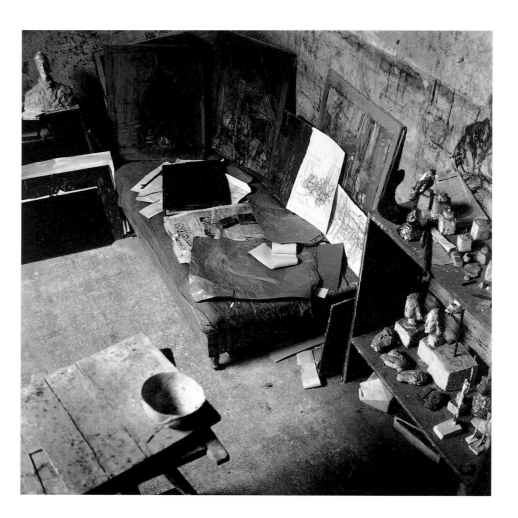

Fig. 1 Corner of Giacometti's studio, c. 1953.

If Switzerland had been a time of failure and frustration, Paris proved to be a wonderful home-coming. As Giacometti made his way from the station towards Montparnasse, he noticed with pleasure and relief that the city, which had been occupied by the German army when he left, appeared to have changed little enough during his absence. The streets looked grimier and the buildings more dilapidated than before, but that made them all the more poignant to Giacometti, who was particularly pleased to note that the cafés and bars he had so enjoyed between long bouts of solitary work were still open for business. What delighted him most of all, though, when he arrived at the old, ramshackle building on rue Hippolyte-Maindron where he lived, was to find his studio exactly as he had left it, right down to the rubble on the floor and the last, hastily abandoned brush and plaster-caked modelling knife.

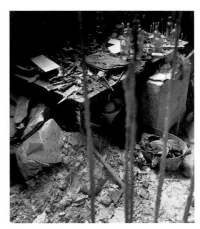

Fig. 2 Working Table in Giacometti's studio, c.1960.

Just behind Monparnasse, the studio was the centre of Giacometti's world; and many of the psychological hardships of his Geneva years seemed to fall away the moment he was able to resume his daily working pattern there. Like most artists, Giacometti depended on a certain routine. He had found this modest, comfortless space in 1927, five years after having first arrived in Paris, and though for a long time he had thought of it as a temporary solution, it gradually became indispensable to him. For one thing, the more he worked there, the more the unprepossessing little room became the archive of his struggle with appearance and reality, hope and failure. Paintings and sculptures of every phase of his career stood round the chaotic space (like 'guardians of the dead', as the writer Jean Genet would say later). But the archive went much deeper. In the rubble on the floor lay hundreds of abandoned sculptures and scraped-off images, as well as scores of crumpled drawings and rapid, forgotten notations. Filled with finished images and the ghosts of rejected ones, the studio seemed to embody a lifetime of work, right down to the sketches that had been scratched into the wall, and the odd jottings, memos and telephone numbers that surrounded them.

Since Giacometti tended to sleep in the studio as well (unless he was in funds, or ill, and treated himself to a room in a local hotel), he also felt totally free to begin or stop working whenever he pleased. Being obsessive, perfectionist and immensely driven, that meant that he worked at all hours. But as he rediscovered his bearings in Paris, he gravitated towards a set routine, rising some time after noon, going out for his belated breakfast coffee, working until

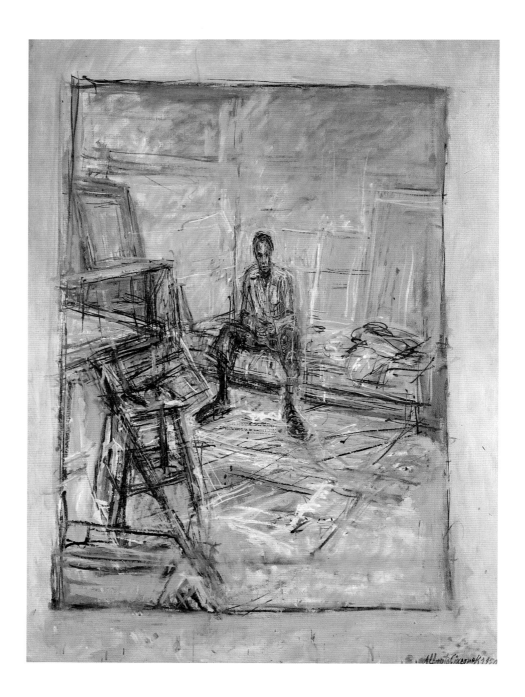

Fig. 3 *Diego*, 1950. Oil on canvas, 80 × 58.4 cm. Robert and Lisa Sainsbury Collection, University of East Anglia.

early evening, having a light meal at a local café, resuming work, going out to Montparnasse or Saint-Germain for drinks and dinner around midnight, then returning and taking up the quest for the ever-elusive image until he heard the first neighbour in the building's courtyard get up and prepare to go out to work.

Giacometti knew whom he had to thank for keeping his studio in the exact, precisely planned chaos in which he had left it before trav-

elling to Switzerland on the last day of 1941. His brother Diego, who had an even smaller work room on the other side of the alleyway to Alberto's, had spent the duration of the war in Paris, getting by as best he could and making sure that their shared sanctuary in the rue Hippolyte (as the brothers called it) came to no harm. For Alberto, an important part of the pleasure and relief he felt at finding his studio unchanged lay in being reunited with his younger brother. In the very early days, when Diego had just arrived in Paris, both of them had slept in the little studio, Alberto downstairs, Diego on the narrow, wooden gallery that ran along the back wall. Later Diego had moved out, found himself a room, as well as a mistress, in the area; and when a place became vacant in the rue Hippolyte, he took it on as a working space where he could help his brother with some of the more manual and practical aspects of making sculpture. They had worked closely together before the war when, to raise money to live on, they had designed objects such as lamp bases and door handles for the well-known interior decorator, Jean-Michel Frank. Diego's ability to make anything with his hands stood the two brothers in good stead, and he was soon entirely responsible for making the delicate armatures for his brother's sculptures, overseeing the casting of the plasters at the foundry and, eventually, for achieving the exact patina that Alberto required for each bronze.

Fig. 4 *Portrait of the Artist's Brother*, 1948. Pencil on paper, 49 × 31 cm. Robert and Lisa Sainsbury Collection, University of East Anglia.

But Diego was far more than 'another pair of hands' for Alberto. He was a constant presence, a reminder of their shared childhood in the Val Bregaglia and a direct link to their mother, Annetta, who continued to be the most important person in Alberto's life even when he was far away and deeply absorbed by his Parisian existence. Being always on hand meant that Diego had another huge advantage for his brother. He could model for him, at virtually any moment of the day or night — an exacting and often inconvenient task that Diego undertook with stoic dignity, holding a pose for hours while his brother moaned and cursed the impossibility of ever achieving the least detail of what he saw before him. As the artist's most constant model, Diego became all men to Giacometti; and when we look at the pared-down, sculptured features so redolent of postwar existentialism and urban anxiety, we are in fact seeing the craggy face of a man brought up in a Swiss mountain village.

Settling back into his studio routine and having Diego again on hand was deeply reassuring for Alberto, but other satisfactions,

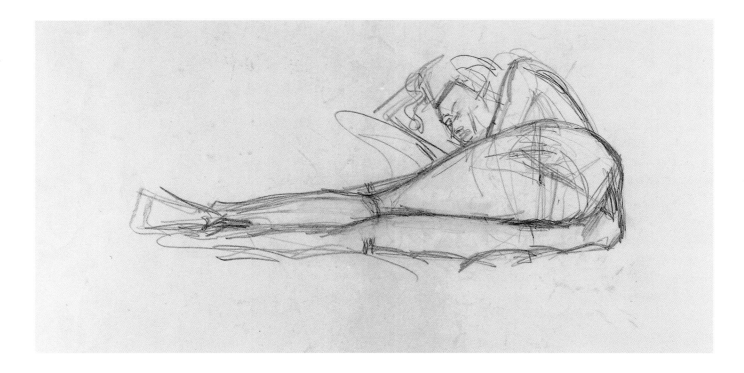

Fig. 5 *Isabel Reclining*, 1940. Pencil on paper, 30.5 × 45.7 cm. Robert and Lisa Sainsbury Collection, University of East Anglia.

which he had longed for during the Geneva years, were about to come. He had written several letters to Isabel during that self-imposed exile, describing the frustrations he had undergone while he attempted to recreate his vision of her standing at midnight on the Boulevard Saint-Michel. Isabel's free-and-easy vitality and her extraordinarily mobile features — which could turn from haughty disdain to raucous laughter in an instant — had not ceased to entrance Giacometti (as they would later fascinate Francis Bacon). When artist and model met again shortly after Giacometti's return to Paris, they became lovers. They lived together at the rue Hippolyte for only about three months, but the consummation of their affair appears to have helped Giacometti significantly in breaking through the impasse in which his work had become trapped.

Signs of this became evident when Giacometti agreed to have his recent sculptures reproduced in the first postwar issue of the highly influential review, *Cahiers d'Art*. Beside the tiny heads and figures stood slightly more substantial figures, while beneath the illustrations a caption cautioned that these works were 'still in progress'. Around this time, another incident occurred which helped convince Giacometti that he was making a breakthrough towards a new way of seeing. It came as he was watching a film in a Montparnasse cinema, and he was to recall the experience frequently in later years:

It happened after the war, around 1945, I think. Until then…there was no split between the way I saw the outside world and the way I saw what was going on on the screen. One was a continuation of the other. Until the day when there was a real split: instead of seeing a person on the screen, I saw vague black blobs moving. I looked at the people around me and as a result I saw them as I had never seen them…I remember very clearly coming out on to the Boulevard du Montparnasse and seeing the Boulevard as I had never seen it before. Everything was different: depth, objects, colours and the silence… Everything seemed different to me and completely new…It was, if you like, a kind of continual marvelling at whatever was there…That day reality was completely revalued for me; it became the unknown, but at the same time a marvellous unknown.[3]

This key experience became an article of faith, a kind of Pauline conversion for Giacometti, confirming that what he had been looking for was not a new way of making sculpture but something both more humble and infinitely more ambitious: a new way of seeing the everyday world. From that moment of revelation onwards, he claimed to have only one aim: to reproduce as accurately as possible what he saw; and later, despite his prodigious facility as a draughtsman, he repeatedly claimed that nothing was so impossible to reproduce in an image as the root of a nose or the curve of an eyeball.[4] The experience in the cinema manifestly spurred Giacometti's efforts to reformulate his entire understanding of the visible world, however traumatic and alienating the transition proved to be. He had been deeply disturbed by a series of other revelations which he described in a text, *Le rêve, le sphinx et la mort de T.* (The Dream, the Sphinx and the Death of T.), written during the same period in an attempt to clarify his abruptly and frighteningly altered relationship with reality:

During that period I had begun to see heads in the void, in the space that surrounded them. The first time I saw a head I was looking at freeze, become fixed in that single instant forever, I trembled with terror as never before in my life, and a cold sweat ran down my back. This was no longer a living head, but an object which I looked at as I would look at any other object; yet not quite, not like any other object, differently, like something that was dead and alive at the same time. I let out a cry of terror as if I had just crossed over a threshold, as if I had gone into a world that nobody had seen before. All the living were dead, and this vision came back often….[5]

Around the same time, Giacometti took up painting regularly again, having all but abandoned it since 1925, and for long periods he practised it in counterpoint to his sculpture, which became increas-

ingly pictorial as a result and conceived, like a picture, to be viewed from the front. He also drew, feverishly and continuously, both in the studio and on whatever scrap of paper came to hand while he was talking in a café or waiting in a restaurant. Drawing became more and more the most spontaneous and revealing of Giacometti's activities, a constant diary he kept of the people who came into his life and the objects which fascinated him, as simple and as difficult to capture as a flower or the fold in a tablecloth. Drawing served him as the most direct way of grasping reality, of rehearsing a situation or trying to solve certain problems he had encountered in sculpture and painting. As time went on, Giacometti would talk about drawing as the essential source of his art, the matrix in which all forms originated. 'There is no difference between painting and drawing,' he said. 'I have been practising them both differently, with each helping me to do the other. In fact, both of them are drawing, and drawing has helped me to see'. 'If one knew how to draw,' he claimed on another occasion, 'one could do all the paintings and all the sculptures one wanted to do'.[6]

Yet in whatever medium he was working, and however astonishing his technical prowess, for the rest of his career Giacometti remained painfully conscious of the impossibility of the task he had set himself: to copy exactly what he saw. To achieve it, he had been prepared to accept years of failure, to court ridicule and despair; but he knew that this seemingly modest goal was the most ambitious any artist could devise, since it implied catching life in all its transience. The ambition had nothing to do with elaborating a new style, but with attempting to record the appearance of things as if they were not immobilized in forms and colours but still moving and changing in the uninterrupted flux of time. It was indeed a daunting aim. 'You never copy the glass on the table; you copy the residue of a vision,' Giacometti once remarked, '...each time I look at the glass, it has an air of remaking itself...One sees it disappear, then reappear...which is to say that it is really always between being and non-being. And it is that that one wants to copy...'[7] In another, more sombre mood, he wrote: 'The days pass and I delude myself I am trapping, holding, what is fleeting.'[8] But with the lucidity he applied to all his experiences and endeavours, Giacometti also recognized that it was the undertaking's very impossibility which excited him and kept him locked in the daily struggle to get closer to overcoming it. 'It doesn't matter whether I fail or I succeed,' he remarked, echoing a sentiment

often expressed by his friend Samuel Beckett. 'In fact, failure and success are the same thing.'[9]

In the summer of 1946, as Giacometti's confidence in his creative powers was increasingly restored, another event happened that was to have far-reaching consequences for the artist's life. Along with the émigré artists and intellectuals he had frequented in Geneva (which included the painter Balthus), Giacometti had got to know a variety of young admirers from the local population. One of these was Annette Arm, a slim, attractive woman more than twenty years his junior. Giacometti had long been aware that, when it came to relationships with the opposite sex, he was most at ease with prostitutes; he had found this out as a young man, and indeed he remained an habitué of certain brothels and prostitute bars in Paris for the rest of his life.[10] This habit also seemed to accord better with a life devoted entirely to wrestling images out of the void at all times of day and night in conditions of near-squalor. Perhaps the brief intensity of his affair with Isabel, who was used to artists and famously uninhibited in sexual matters, had encouraged him in the illusion that he could share his harsh existence with a woman. At all events, when Annette made it clear that she wanted to follow him to Paris, Giacometti did not dissuade her.

When she arrived, Annette was allowed to move directly into Giacometti's studio, much to his friends' surprise, becoming part of the artist's everyday life, posing for him during the day and going out with him at night. It should have been clear from the start that, although he was deeply fond of his girlish new companion, Giacometti was in no way prepared to change his style of life to satisfy the needs of a wife (they were not in fact married until July 1949). Nevertheless, as a concession, he rented the room next to the studio as a bedroom for them both, and to soften its grim discomfort he painted a still-life for Annette on one of the pitted, peeling walls. No household comforts were forthcoming, however. Furniture was kept to an absolute minimum, while cooking and washing facilities were next to non-existent. Money remained extremely scarce. Although Giacometti sold the odd drawing, his tiny sculptures drew amusement and wonder, but no buyers. For much of the time, in the years immediately following the war, Giacometti had to rely on a little cash sent by his mother or borrowed from friends; even then, food and coal for the studio stove remained in short supply.[11] There were times, particularly during the bad winter of 1946–47, when the sculptor could not work because there was no fuel to heat his icy studio. Lack of funds did not unduly disturb the Giacomettis, however. Living conditions in postwar Paris were gener-

ally harsh, with accommodation of any kind hard to come by and regular shortages of even the most basic necessities. To a large extent these hardships were compensated for by the heady atmosphere of liberation and renewal that permeated the city. Coffee and countless cigarettes apart, Giacometti himself was used to living on very little, and Annette was prepared, at least during the early years of their life together, to share his spartan regime.

Among the friends the new couple saw frequently in Saint-Germain-des-Prés were Jean-Paul Sartre and Simone de Beauvoir, who chronicled the period closely in her diary and her extensive correspondence. In a letter written in English to her lover, the American writer Nelson Algren, de Beauvoir gave this poignant aperçu of the Alberto-Annette ménage in rue Hippolyte:

> I don't think I have had the chance yet to tell you about a very great friend, a sculptor whom we are always very glad to see [...] Yesterday I visited [Giacometti's] house, it is enough to frighten anyone. In a charming little forgotten garden he has a studio, drowning in plaster, and he lives next to this in a kind of hangar, vast and cold, with neither furniture nor food. [...] Since there are holes in the ceiling he has put pots and boxes on the floor to catch the rain, but the pots and boxes have holes in them too! He works very hard for fifteen hours at a stretch, above all at night, and whenever he goes out his clothes, his hands and his thick, matted hair are covered with plaster – he takes no notice, he works. I admire his very young wife for accepting this life; having spent the day as his secretary, she goes back to their desperate lodgings, she does not have a winter coat and she wears worn-out shoes. In order to come to Paris to live with him she has left her family and everyone; she is very nice. He is very attached to her but since he is not the tender sort she has some hard times[12].

Although he had not taken too kindly to Annette's eruption into the exclusive, daily relationship he had until then enjoyed with his brother, Diego continued to assume all the tasks his brother asked of him, including advancing an opinion as to how well a particular sculpture or painting was coming along. Alberto trusted Diego's judgment above everybody else's since he knew that his brother not only had no illusions about him but would never equivocate about what he thought. Naturally, Diego also went on accepting the rigours of sitting regularly to his brother. Giacometti had always held that a single human face – or indeed a tree or a glass – could provide an artist with all the necessary subject matter to fill a lifetime of work. 'The great adventure,' he said once, 'is to see something unknown appear every day in the same face'[13]. If he found this in Annette, he

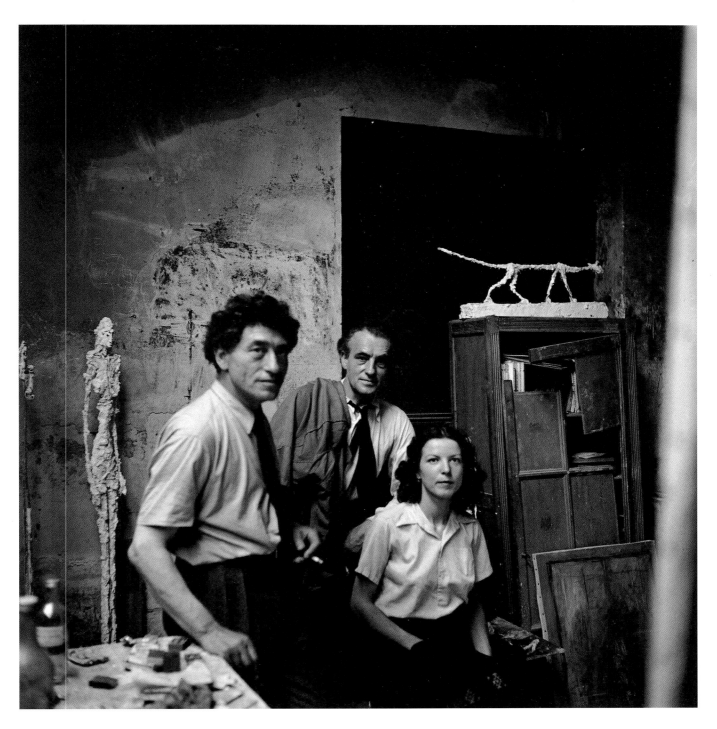

Fig. 6 *Alberto with Annette and Diego*, 1952.

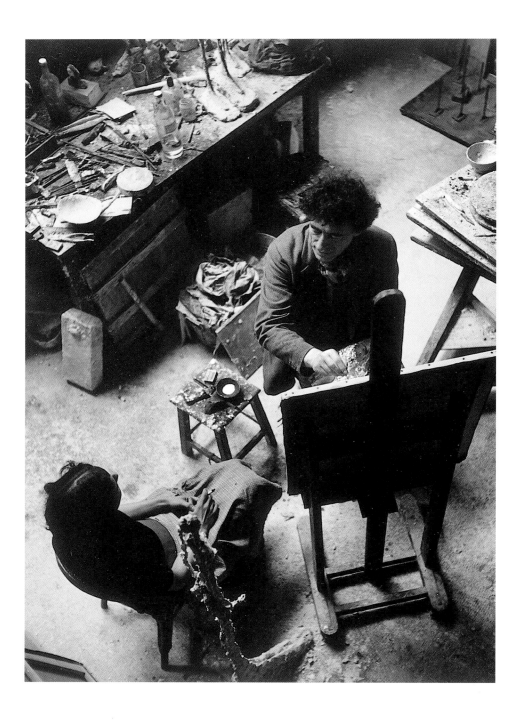

Fig. 7 *Giacometti Painting Annette, c.* 1960.

found it even more powerfully in Diego, whose appearance he had been stalking since boyhood. 'He (Diego) has posed ten thousand times for me,' he remarked towards the end of his life. 'When he poses I don't recognize him. I want him to pose so that I can see what I see. When my wife poses for me, after three days she doesn't look like herself. I simply don't recognize her[14].' And the poet Jacques

Dupin remembers that one evening, after Annette had posed for him all afternoon, Giacometti was staring at her with particular intensity. 'Why are you looking at me like that?' she asked. 'Because I haven't seen you all day,' Giacometti replied[15].

However gruelling the session in the studio had been, with the constant dissatisfactions which his relentless demands provoked, Giacometti's easily recognizable silhouette — great head of tousled hair, plaster-caked clothes — would invariably be seen towards midnight in one of the main cafés in Montparnasse or Saint-Germain-des-Prés. The curfew that the Germans had imposed already seemed a distant memory: the restaurants were brightly lit again, and new cabarets and jazz clubs were starting up in basement cellars all over the Latin Quarter. Giacometti became almost as resolute in his pursuit of company at night as he had been in pursuit of an image during the day, and despite his apparently solitary studio life, he knew everybody who counted in Paris's intellectual circles.

Contrary to what might have been expected in the immediate aftermath of the occupation, that whole milieu was unusually exuberant, the sense of relief at having survived the horrors of war balanced by the hope of radical change. Many intellectuals and artists whom the recent cataclysm had dispersed far and wide now flocked to Paris, which for the following decade was to regain its aura as the cultural capital of the West; and the sense of excitement, of new ideas and inspired seeking, was almost tangible on the thronged terraces in front of the Café Flore and the Deux Magots. These two cafés became the undisputed hub of Saint-Germain's intellectual life. Sartre received so many telephone calls at the Flore that the owner put in a line especially for him and later advertised the café as the 'Rendez-vous des existentialistes'; not to be outdone, the Deux Magots billed itself as the 'Rendez-vous de l'élite intellectuelle'. With many of its habitués lodged in comfortless pensions and leading a precarious existence, life in Saint-Germain was lived with unusual intensity right round the clock: 'We wanted to change the world during the daytime, and exchange ideas at night,' the French writer Claude Roy remembers[16]. Reduced to its simplest form, 'existentialist' philosophy sparked off an enormous, spontaneous reaction. 'Man is nothing else but what he makes of himself…', Sartre had intoned in *Being and Nothingness*. Taken up and bandied around, phrases such as these, coming after years of fear and restriction, electrified the new, postwar generation. 'Day and night with our friends, chatting, drinking, wandering, laugh-

ing, we celebrated our deliverance,' Simone de Beauvoir, Sartre's constant companion, noted in her diary[17].

Giacometti's renewed friendship with Sartre, whom he had first met in 1939, brought the artist into contact with a new circle of people, and most importantly with the philosopher Maurice Merleau-Ponty, whose work on the nature of perception fascinated Giacometti. This subtle thinker's investigations into the varieties of perceptual experience, such as the radical differences between a newborn child's and an adult's way of seeing, seemed to Giacometti to elucidate the 'visions' he himself had experienced, notably after leaving the cinema on the Boulevard du Montparnasse. At the same time, in the easy ebb and flow of Paris café life, Giacometti continued to meet many of his prewar friends regularly, notably Balthus, the writers Michel Leiris, Georges Bataille and Louis Aragon (all friends from the Surrealist period), publishers such as Tériade, Christian Zervos and Albert Skira (whom he had come to know well in Geneva), and dealers like Pierre Loeb. For a while he also saw a great deal of Picasso, mostly because of the latter's fascination with a powerful, individualistic temperament and an artistic ambition so different from his own. At one point Giacometti made a bust of Picasso, but it was later destroyed. Their friendship began to cool during the early 1950s, then ceased altogether, with Giacometti waxing censorious whenever Picasso's name or work cropped up in the conversation.

Throughout the late 1940s, Giacometti's relationship with Sartre, whom he portrayed several times, proved particularly stimulating and fruitful. Both men had a love of sustained discussion and they met regularly simply for the pleasure of sounding ideas off each other. Giacometti impressed Sartre by the agility of his arguments, even if they led him at times to defend the most absurd positions, and he in turn was greatly taken by the writer's dazzling brilliance on any subject, however lofty or mundane, as well as by his reputation as the rising star of postwar philosophy. Sartre's first essay on Giacometti, *The Search for the Absolute*, proved immensely influential and did much to cast the artist, however tendentiously, in the role of the existentialist hero, engaged in a lonely struggle which he knew would end in failure. The interpretation, which contained brilliant insights and gave Giacometti's singular artistic exploration the beginnings of a formidable theoretical framework, dominated subsequent writing on the subject, often at the expense of the work's primarily visual qualities: the force with which it absorbed and energized space, turning the smallest, pencil-hatched head into a source of compelling, sombre radiance.

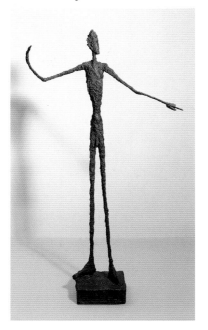

Fig. 8 *Man Pointing*, 1947. Bronze, 178 × 95 × 52 cm. By Courtesy of the Trustees of the Tate Gallery.

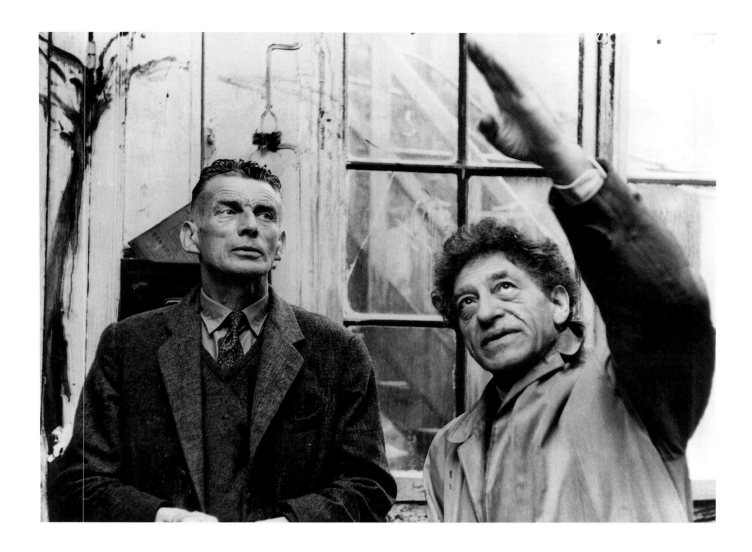

Fig. 9 *Samuel Beckett with Giacometti*, 1961.

Giacometti was particularly drawn to relationships with writers, and his friendship with the ex-convict poet and playwright Jean Genet was in many ways the most fascinating of all of them. Giacometti, who once exclaimed without apparent irony how handsome he found Sartre, had been excited by seeing Genet's bald, domed skull catch the light in a café. When the two met, they found they had a great deal in common, including a marked sympathy with the underworld and others who lived outside normal social conventions. On the artist's side, the friendship gave birth to two striking portraits and numerous drawings of Genet; on the writer's, to a wonderfully perceptive, lyrical account of the artist's universe. It was, Picasso said, the best book he had ever read about an artist; and there can be little doubt that Genet came closest to describing the secret source of Giacometti's art. 'Beauty has no other origin,' Genet wrote,

'than the wound, singular and different for each of us, that every man keeps within himself, that he guards and withdraws to when he wishes to leave the world for a temporary but profound solitude.'[18]

Another intriguing friendship was the one that led Giacometti into nightly rambles across Paris in the company of the then little-known writer, Samuel Beckett. These walks, which included visits to the Sphinx and other brothels, were not accompanied by effusive talk, since Beckett was famously reserved and not to be drawn. But a real sympathy, above all in their shared understanding that to be an artist was to fail repeatedly, indeed be devoted to failing as the only sign that one's sights had been set high, grew up between the two men, who were to become, perhaps, the world's two best-known failures. Thus, when *Waiting for Godot* was put on at the Théatre de l'Odéon in 1961, the by-now famous Beckett asked his similarly famous sculptor friend to create the minimal set (a single, plaster tree, as it turned out). Unfortunately Giacometti never portrayed the Irish writer, who may have felt too self-conscious to pose for him; and Beckett never wrote about the artist, although it would not be difficult to imagine a Beckett monologue issuing from a Giacometti-like figure faced by the absurdity of his predicament while trapped to the neck in the rubble of his sculptor's cave.

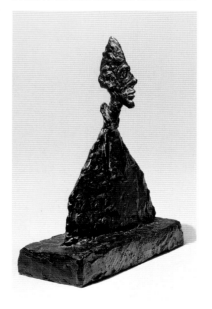

Fig. 10 *Thin Bust on Plinth (Amenophis)*, 1954. Bronze, 39 × 32 × 13 cm. Private collection.

By the early 1950s, Giacometti's sculptures had grown into the tall, emaciated figures with deeply kneaded flesh and obsessive, distant stares that were to become the basis of the imagery that he developed, still tirelessly making and destroying, until the end of his career. Within that particular confine (to Giacometti as wide, as rich and as variable as the entire visible world), there were continuing struggles with scale and proportion, deformation and verisimilitude, space and colour. The style fluctuated and evolved, but the subject — essentially, a loved or known human being, sitting at a precisely measured distance from the artist or recreated from memory — had been defined long ago. It was not art from art, although Giacometti had absorbed so much from the past, but art from palpable, human life, caught in the passage of time and held in a web of contours and lines for the curious gaze of posterity. Hieratic and reduced to the bone, Giacometti's mature sculptures also seem to be responding to a long call from antiquity. Even the drawings, as tenacious as they are tentative, create an aura of having survived the vicissitudes of centuries. 'I work to please the dead,' Giacometti commented once; and already his figures have assumed an existence beyond the tomb,

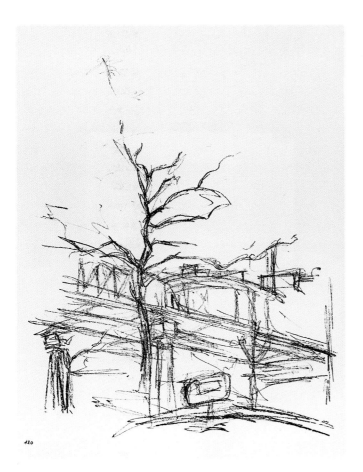

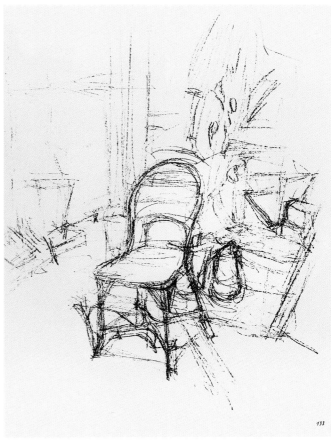

communing as much with the long deceased – of ancient Egypt, Sumeria and Chaldea – as with those not yet born.

By the time Giacometti's distinctive, postwar style was established and his work began to attract international attention, notably in the United States, Paris itself had emerged from the aftermath of the war. Commodities became less scarce, the sense of liberation lost its impetus, and as the new threat of the Cold War loomed, memories of the Occupation were buried with all too great a haste. Giacometti continued his round of work at all hours in the studio punctuated by a late supper and drinks with friends in the cafés. Between the rue Hippolyte-Maindron, the bars of Monparnasse and the occasional foray into a quartier beyond, Paris provided the artist with everything he wanted. Above all, it provided him with a mental landscape, a milieu which put him on his mettle and stimulated his daring and his intransigence. Since Giacometti had first come to live there in 1922, Paris had been implicit in virtually every image he made. It was the city where his greatest illuminations and his worst night-

Figs 11 and 12 Two lithographs from *Paris sans fin*, 1969. Both 45.3 × 35 cm. Robert and Lisa Sainsbury Collection, University of East Anglia.

mares had occurred: where he had glimpsed Isabel dwarfed by the immense night, feared the corpse's icy hand on his arm, seen reality abruptly transfigured and watched the living become the living-dead, their mouths opened in silence.[19]

It was not until the last years of his life, when he was already gravely ill, that Giacometti found the opportunity to pay a direct tribute to Paris. Under the title he himself had chosen, *Paris sans fin* (Paris Without End), the artist made a long series of lithographs celebrating the cafés, boulevards and vistas of the city which meant most to him.[20] The drawings were made from various vantages: from the street, from a café table or even from a car, with scenes sketched down in a slightly skewed perspective through the windscreen.[21] Made *sur le motif* with lithographic chalk on transfer paper, the 150 images follow one another like disjointed stills from a film, moving from a familiar street corner to the towers of Saint-Sulpice, a few figures at the bar, then back to the sparse outline of a tree against a vacant city sky.

Having for once forsaken his four walls and the study of a single head, Giacometti seems overwhelmed by the variety of this vast, outside world: his hand races from one subject to the next with a feverish intensity, as if he felt there would never be time to capture even a fraction of these fleeting instants. The lines swoop, encircling each scene with endless hesitations, as if coaxing rather than willing the forms into the flow of life. More than ever there is an almost vertiginous sense of flux: of buildings, streets and objects moving ceaselessly under one's eyes, never the same from one glance to the next and never to be copied as they really are. As the great draughtsman of transience, Giacometti revels nostalgically in the sense that a city is as changing as a human face, and hence as mortal. Being infinitely aware of the passage of time, he had spent his entire life searching for ways to encapsulate it, so that his astonishment at the uniqueness of everyday life would remain intact. In these late images, published after the artist's death, Giacometti's quest and the city he loved became one.

1 Giacometti had originally left Paris thinking he would return within a couple of months.

2 *Née* Nicholas, Isabel was to become successively Isabel Delmer, Isabel Lambert and Isabel Rawsthorne. In her memoirs she describes how she met Giacometti: 'I had been aware of a curious sensation when being observed with remarkable intensity by a man with singular features. This continued for many days until one evening, as I rose from the table, he rose at the same time. Advancing, he said, "Est-ce qu'on peut parler?" From then on, we met daily at 5pm. It was many, many months before he asked me to his studio and to pose. By which time I knew that he had changed my life definitely.' (Quoted in the catalogue to the exhibition *Isabel Rawsthorne (1912–1992): Paintings, Drawings and Designs*, The Mercer Art Gallery, Harrogate, 1997).

3 From an interview in Georges Charbonnier: *Le Monologue du peintre*, Paris, 1959. This and the other longer quotations from the French in this essay have been translated by the author.

4 This very characteristic conviction – that he would never be able to copy what he saw – began in 1934 and heralded Giacometti's split with the Surrealists.

5 This text is published in its first, full English translation on p. 29.

6. Alberto Giacometti: 'Je ne sais ce que je vois qu'en travaillant', Paris, 1993, p. 8.

7 André Parinaud: 'Entretien avec Giacometti – Pourquoi je suis sculpteur', *Arts*, no. 873, 13–19 June 1962.

8 From the poem 'Un aveugle avance la main dans la nuit' in *Alberto Giacometti: Ecrits*, Paris, 1997.

9 'To be an artist is to fail, as no other dares fail,' Beckett observed in a rare interview, having given an unforgettable description of his own predicament: 'The expression that there is nothing to express, nothing with which to express, nothing from which to express, no power to express, no desire to express, together with the obligation to express.' (*Three Dialogues with Georges Duthuit*, New York, 1984).

10 Jean Genet noted perceptively: 'He misses the brothels that are now all closed down. I think they had too big a place in his life, and now in his memory, for one not to talk about them. It seems to me he went to them almost as a worshipper. He went there to see himself kneeling in front of an implacable, distant goddess. Between each naked whore and him there was perhaps the same kind of distance that his statues always keep with us.' (*L'Atelier d'Alberto Giacometti*, Paris, 1958).

11 Bruno, the youngest Giacometti brother, recalls that Alberto continued for a long time to receive money from his family in Switzerland, which ensured that he was never altogether indigent. Conversation with the author, Zurich, February 2001.

12 Simone de Beauvoir: *'Beloved Chicago Man', Letters to Nelson Algren 1947–64*, London 1998, p.98.

13 André Parinaud, op. cit.

14 Pierre Dumayet: 'Le drame d'un réducteur de têtes: Giacometti', *Le Nouveau Candide*, Paris, 6 June 1963.

15 Jacques Dupin: *Alberto Giacometti*, Paris, 1962, p.77.

16 Claude Roy: *Nous*, vol. 2 of *Somme toute*, Paris, 1972. Quoted in Herbert Lottman: *The Left Bank*, San Francisco, 1991, p.239.

17 Simone de Beauvoir: *La Force des choses*, Paris, 1963. Quoted in Lottman, op. cit., p.238.

18 Genet, op. cit., p.2.

19 As described in Giacometti's text, *Le rêve, le sphinx et la mort de T.*, translated into English on p.29.
20 *Paris sans fin* was brought out in a limited edition of 250 copies in 1969. The title came about when Giacometti and the publisher Tériade, a friend of many years, were coming out of a café together. 'Ah Paris…Paris sans fin!,' Giacometti exclaimed. 'You've got your title,' Tériade replied.
21 Caroline, a prostitute who met the artist in 1959 and became both his model and his mistress, drove Giacometti round the city in the sports car he had given her.

FOUR TEXTS BY ALBERTO GIACOMETTI

Michael Peppiatt

Giacometti once remarked that he wouldn't mind being reduced to a human trunk, without arms or legs, as long as someone put him on a chimney piece where he could go on talking to his friends gathered together in a room.[1] He loved conversation, and brought to it the passion for discovery and truth that kept him in pursuit of a particular vision in art. Whenever that obsession allowed him a little leeway, he would continue a similar pursuit in words, making, destroying and remaking an argument, never satisfied and often prepared, once a point had been brilliantly driven home, to plead the opposing view. He engaged in these verbal jousts not only with great masters of the art, such as Jean-Paul Sartre or Jean Genet, but also with anyone who aroused his sympathy or curiosity during the nightly odyssey which took him from restaurant to café or bar in Montparnasse and Saint-Germain-des-Prés. Few people, inevitably, managed to keep pace with this relentless probing, proving and disproving, and occasionally Giacometti's frustration would show through, leading him at one moment to exclaim that he would give his life's work for one good conversation.

This love of words spilt over very naturally into a desire to write – to explore more formally and give clearer shape to the kinds of themes and obsessions he chewed over relentlessly with his friends. Early in his career Giacometti had joined the Surrealists and been surrounded not only by people for whom writing was second nature but also by all kinds of literary investigations, verbal games and manifestos. The opportunity to publish was easily at hand, too, and from 1931 the sculptor began to contribute to a number of reviews that André Breton's group, or its dissidents, had spawned. Deeply influenced by the Surrealists' interest in psychoanalysis, these early texts are above all explorations of the self perceived at a subliminal level where dream and reality, fear and desire, chance and coincidence merge seamlessly into one another.

The two longer texts translated below, *Hier, sables mouvants* (Yesterday, Quicksands), and *Le rêve, le sphinx et la mort de T.* (The

Dream, the Sphinx and the Death of T.) belong to this category, even though the latter was written in 1946, a good ten years after Giacometti had ceased to be a member of the Surrealist movement.[2] Moreover they both carry a sense of urgency, as if the sculptor had turned to words in a determined attempt to make sense of certain obscure, troubling areas of his life. These two texts are widely considered to be the most important and revealing of all his writings. They have been quoted extensively in English before, but (although both texts exist, for instance, in German) this is the first time that they have been translated into English in their entirety.[3]

Giacometti continued to write up until his death, with several important texts, such as the preface to his long suite of lithographs, *Paris sans fin* (Paris without End) being published posthumously in 1969. Most of these texts were written with a specific purpose in mind. In a particularly important letter to Pierre Matisse, for instance, the artist sets out to give his New York dealer a rapid overview of his development as a sculptor; and parts of the letter appeared, with marvellous thumbnail sketches of the works in question, as the catalogue introduction to his show at the Matisse Gallery in 1948. Others were tributes to artists he admired – notably Henri Laurens, Georges Braque and André Derain – or answers to the kind of questionnaire that art magazines continued to send out long after the Surrealists had made such intellectual opinion-gathering fashionable. *Ma réalité*, the third of the texts published in English here, is a particularly concise case in point, where Giacometti rises to the occasion of stating his bearings in existence with admirable freedom and directness.

As well as being a voluminous and very conscientious letter-writer, Giacometti was also a great scribbler of notes, odd phrases, key words and aide-mémoires. In the studio he would jot these down on anything that came to hand, but he also kept little notebooks which he would stuff into his jacket pocket and take out whenever a thought came to him – in the street, at a café table – that he felt like recording. *Tout cela n'est pas grand'chose* (All that is not so very much) was a jotting made shortly before his death, and although it is only a couple of lines long, it shows how conscious Giacometti remained, at the height of international acclaim, of the very relative importance of art when considered in the longer view of man's fate. 'Art interests me very much,' he once remarked succinctly. 'But truth interests me a great deal more.'

Giacometti never considered himself a writer as such, and on several occasions he expressed rage at his 'total deficiency' or lamented

that he did 'not know enough about the meaning of words or the way they work together'.[4] Nevertheless, his published writings, prefaced by two of his close poet friends, Michel Leiris and Jacques Dupin, constitute a sizeable volume and, for any serious student of Giacometti's art, they are worth reading *in extenso* because they mirror his unusual cast of mind in such a variety of moods and often — since the artist himself had presumably never imagined such fragments would ever become public — at its most spontaneous, unguarded and occasionally downright quirky.

Most of the texts, including all four included here, were originally written in French, although a small number of the shorter texts found in Giacometti's notebooks were written in Italian. The artist's native tongue was, in fact, neither language but an Italian dialect spoken in the Val Bregaglia region of Switzerland where he was brought up. Although Giacometti turned out to have a gift for languages (he picked up fluent German at school, for instance), the French he spoke and wrote in remained highly personal, not to say idiosyncratic, with constructions and turns of phrase that seem to have been imported from another linguistic system. Nevertheless, the experiences that prompted these complex meditations on love and death have been deliberated with an overriding concern for clarity, and however unexpected the mental leaps and repetitions sometimes appear, the translator soon realizes that the best way to convey the artist's thought is by staying as close as possible to the rhythm of the original. Giacometti wrote very much as he drew, with a hesitating, questioning line which circles back on itself repeatedly, then stops abruptly and breaks off, leaving an intense concentration of thoughts stretched like a spider's web over a void.[5] In the texts, as in the images, there is never an end, only a suspension, since every effort to fix a truth is doomed to be both partial and transitory. The title Giacometti gave to the first of the texts published below, *Quicksands*, surely had a wider significance for him. Were not all attempts to trap an appearance or record a sensation destined to disappear, engulfed slowly but inevitably into the quicksands of time?

1 Michel Leiris recounts this anecdote in his preface to *Alberto Giacometti: Ecrits*, Paris, 1997.

2 *Hier, sables mouvants* was first published in *Le Surréalisme au service de la révolution*, no. 5, 1933; *Le rêve, le sphinx et la mort de T.* came out originally in *Labyrinthe*, no. 22/23, 1946.

3 Long extracts from both these texts have appeared in James Lord's biography *Giacometti*, New York, 1983 and David Sylvester's *Looking at Giacometti*, London, 1994.

4 The first quotation comes from Giacometti's text on *Henri Laurens*; the second from the concluding lines of *Le rêve, le sphinx et la mort de T.*

5 In his introduction to *Alberto Giacometti: Ecrits* (op. cit.), Jacques Dupin makes an extended and illuminating analogy between the way the artist wrote and the way he drew.

YESTERDAY, QUICKSANDS

Alberto Giacometti

When I was a child (between the ages of four and seven), the only things I noticed in the outside world were those that could give me pleasure. They consisted mostly of stones and trees, and seldom more than one thing at a time. For at least two summers I remember seeing nothing around me but a large stone about 800 metres from our village – that stone alone and the things directly connected to it. It was a monolith, golden-yellow in colour, and at ground level it opened into a cave. Water had been at work on it, and its whole lower part was hollow. The opening was long and low, no taller than we were at that time. Here and there the insides had been eaten away further, so that there seemed to be another, small cave right at the back. My father had shown us this monolith one day. It was an extraordinary discovery: I immediately thought of this stone as a friend, a being filled with the best intentions towards us: calling us and smiling at us like someone whom we had known before and loved and rediscovered with boundless surprise and joy. It immediately absorbed our entire attention. From that day on, we spent all our mornings and all our afternoons there. There were five or six of us children, and we were always together. I woke up every morning and looked for the stone. From the house I could see it down to the last detail as well as the little path that led up to it like a thread; everything else was vague and substanceless, just air that floated over everything. We went down this path without ever straying from it and we never left the area immediately around the cave. Once we had found the stone, our first concern was to narrow the entrance to it. It had to be a slit just wide enough to let us through. But what gave me the greatest joy was when I could crouch in the small cave at the back: it was barely big enough for me: all my dreams had come true. Once, I can't remember why, I wandered off a little further than usual and came out on higher ground. Breaking through the undergrowth just below me was an enormous black stone shaped like a sharp, narrow pyramid with nearly vertical sides. It's impossible to describe the resentment and confusion I felt at that

moment. The stone struck me right away as a living, hostile and threatening being. It threatened everything: us, our games and our cave. I found its existence unbearable, and I realized right away that since I couldn't make it disappear, I had to ignore it, forget about it and not mention it to anyone. I did go up to it all the same, with the feeling that I was getting into something unworthy, secret and louche. With disgust and fright, I just touched it with one hand. I walked round it, trembling at the thought that I'd find an entrance. There was no cave. That made the stone even more unbearable, yet it gave me some satisfaction: an opening in the stone would have made everything more difficult and I felt how desolate our cave would have been if we had had to look after another one at the same time. I hurried away from this black stone. I didn't tell the other children about it. I ignored it and never went back to see it.

As that time came to an end, I was waiting impatiently for the snow. I wasn't happy until the moment came – which I kept anticipating prematurely – when there was enough for me to go out, alone, with a bag and a sharp-ended stick, to a field at some distance from the village (this was secret work). When I got there, I would try to dig a hole just big enough for me to get into. On the outside nothing was to be visible beyond a hole that was round and as small as possible. My idea was to spread the bag at the bottom of the hole, and I imagined that, once I'd got in, it would be very warm and dark; I thought I would be thrilled... I often had the illusory feeling of this pleasure in the days leading up to it; I spent my time imagining how it should be built, going through every detail of its construction in my mind; I went through every movement beforehand, foreseeing the moment when precautions would have to be taken to prevent the whole thing from collapsing. I was totally caught up with the pleasure of picturing my hole all ready and getting into it. I would have liked to spend the whole winter shut in there alone, and I used to think with regret that I would have to go home to eat and sleep. I must admit that in spite of all my efforts, and probably also because the conditions outside were bad, my wish never came true.

When I started going to school, the first country I thought of as marvellous was Siberia. I saw myself there in the middle of an endless plain covered with grey snow: there was never any sun and it was constantly cold. On one side, quite far from me, the plain was cut off by a forest of fir trees, a dark, monotonous forest. I looked at the plain and at the forest through the little window of an *isba*[1] (this word was essential for me) in which I was standing and where it was

very warm. That's all. But my thoughts used to go back this place very often.*

I remember a similar kind of recurrent demand my mind made: for months during the same period I could not get to sleep in the evening without first imagining that I had crossed a dense forest at dusk and come to a grey castle which stood in the most hidden and forgotten of spots. There I killed two men before they could put up any defence; one of them, about seventeen years old, always had a pale, frightened look, the other wore a suit of armour with something on its left side that shone like gold. I raped two women once I had ripped off their clothes — one who was thirty-two years old and dressed in black with a face like alabaster, then her daughter who wore loosely floating white veils. The whole forest echoed with their cries and their groans. I killed them too, but very slowly (night had fallen by then) and often beside a stagnant green pond in front of the castle. There were slight variations each time. Then I burnt down the castle and fell contentedly asleep.

*PS 1958. On rereading the last paragraph of this text, I realize that when I imagined Siberia I was describing exactly the country where I was and where I was living[2].

1 This came out as *isab* when the text was first published.
2 When he reread this text in 1958, Alberto Giacometti crossed out the last paragraph then added the postscript published here, which in fact refers to the paragraph before last of the present, complete text.

Originally published in *Le Surréalisme au service de la révolution*, no. 6, 15 May 1933.
Extract from *Alberto Giacometti, Ecrits*, © Hermann, Paris, 1991.

THE DREAM, THE SPHINX AND THE DEATH OF T.

Alberto Giacometti

Terrified, I saw an enormous, furry brown spider at the foot of my bed hanging on a thread that led back to a web stretched just over the bolster. 'No! no!' I shouted, 'I can't put up with a threat like that over my head at night, kill it, kill it,' and I said that with all the disgust I felt about doing it myself, both in the dream and when awake.

I awoke at that moment, but I awoke into another dream. I was in the same place at the foot of the bed and at the very moment I said to myself: 'It was a dream', I noticed (I was looking out for it despite myself), I noticed, spread out on a mound of earth and bits of china or little flat pebbles, a yellow spider, ivory-yellow and far more monstrous than the first spider, but smooth, as if covered by smooth, yellow scales, with long, thin legs that looked as smooth and hard as bones. Terror-struck, I saw my girlfriend's hand reach out and touch the spider's scales: she did not seem to feel either fear or surprise. With a cry, I pushed her hand away and, as in the dream, I asked for the creature to be killed. Someone I had not noticed before crushed it with a long stick or shovel, with heavy, violent blows, and turning my eyes away, I heard the scales crack and the strange sound made by the soft parts being crushed. Only afterwards, looking at the remains of the spider gathered on a plate, did I read a name written very clearly in ink on one of the scales; it was the name of that species of arachnids, a name I no longer know, that I have forgotten; I can only make out the separate letters and the black-coloured ink on the ivory-yellow, letters like the ones one sees on stones and seashells in museums. It seemed quite clear that I had just caused the death of a rare specimen in the collection belonging to the friends I was staying with at that time. This was confirmed a moment later by the lamentations of an old housekeeper who came in looking for the missing spider. My first thought was to tell her what had happened, but I saw the disadvantages of this, my hosts' displeasure with me; I should have seen that it was a rare specimen, have read its name and have alert-

ed them rather than kill it. I decided to say nothing, to pretend I knew nothing and to hide the remains. I went out into the grounds with the plate, taking good care as I crossed them not to be seen, since the plate in my hand might look strange. I went to a piece of ploughed earth hidden by thickets at the foot of a slope and, feeling sure that I would not be seen, I threw the remains into a hole that I stamped down, saying to myself: 'The scales will rot before anyone finds them'. Just then I saw my host and his daughter ride past me on horseback; without stopping, they said a few words to me that surprised me and I woke up.

Throughout the following day, I had that spider in front of my eyes. It obsessed me.

The day before, late at night, I had discovered, after looking at the ivory-yellow traces of pus on a sheet of glossy white paper, that I had the disease I had been anticipating for several days. As I took this in, I felt a kind of mental paralysis; it seemed involuntary at first, yet it prevented me from dealing with the threat of illness, which I could have done very easily but did not do. There was no reason for me to think of it as a kind of self-punishment; rather vaguely I sensed that the illness could be useful and give me certain advantages, although I did not know what they might be.

Going to bed that night, and shortly before I had the dream, my girlfriend asked, with a laugh, if she could see the symptoms of my illness.

I had been expecting the illness since the previous Saturday when, at six o'clock, I heard they were going to close the Sphinx[1] for good and I rushed over there: I couldn't bear the thought that I would never again see that room, for me the most marvellous of places, in which I had spent so many hours, so many evenings, since it opened.

That last time I went there I was a bit drunk after a lunch with some friends. During the lunch we talked in passing of the interest there might be in keeping a diary day by day and of everything that would be against it. I had an immediate and quite unexpected desire to start a diary right away, starting at that very moment that we were all together; and, while we were on the subject, Skira asked me to write, for this issue of *Labyrinthe*, the story of T's[2] death which I had told him some time before. I promised to do it without being very clear about how it could be done.

But since this dream, since the illness that made me think of that lunch, T's death has once again become real to me.

Coming back this afternoon from the doctor's, I wondered if the coincidence in time alone of Skira's request and the visit to the

Sphinx, with its consequences, had been enough to bring back the memory of T's death and to make me want to write it down today. Here I should say that as I came out of the chemist's, holding my tubes of Thiayzomides, the first thing to strike me as I stood on the chemist's doorstep on Avenue Junot, only yards away from my doctor's house, was the sign on the little café opposite: 'Au Rêve' [The Dream].

As I walked along, I saw T. again in the days just before his death, in the bedroom next to mine, in the little building at the end of the vaguely run-down garden where we lived. I saw him again, huddled in his bed, motionless, his skin ivory-yellow, withdrawn into himself and already strangely far away, and a little later, at three in the morning, I saw him dead, with his skeletally thin limbs stretched out, opened up and abandoned far from the body, with his enormous, swollen belly, his head thrown back and his mouth open. Never had a corpse seemed so meaningless to me – worthless rubbish to be thrown out like a dead cat into the gutter. Standing motionless by the bed, I looked at the head, which had become an object, an insignificant, measurable, little box. Just at that moment, a fly crawled up to the mouth's black hole and slowly disappeared into it.

I helped get T. dressed as best I could, as if he were going to some glittering occasion, a party perhaps, or as if he were about to leave on an important trip. By lifting, lowering and shifting his head like some kind of object, I got a tie on him. He was oddly dressed. Everything seemed usual, normal, but the shirt was sown-up at the collar, and he had neither belt, nor braces, and no shoes. We put a sheet over him and I went back to work until morning.

Going back into my bedroom the following night, I noticed that by some odd chance no light was on. A.[3] was sunk into the bed, asleep. The corpse was still in the bedroom next door. I disliked the lack of light and as I was about to go naked down the dark corridor leading to the bathroom which went past the dead man's bedroom, I was filled with terror and, although I didn't believe it, I had the vague impression that T. was everywhere, everywhere except in that miserable corpse on the bed, that corpse which had seemed so meaningless to me. T. was beyond all bounds, and terrified of feeling an icy hand touch me on the arm, I made a huge effort to go down the corridor, then came back to bed and with my eyes open I talked to A. until dawn.

I had just experienced the other way round what I had felt a few months earlier in front of living people. During that period I had begun to see heads in the void, in the space that surrounded them. The first time I saw a head I was looking at freeze, become fixed in

that single instant forever, I trembled with terror as never before in my life, and a cold sweat ran down my back. This was no longer a living head, but an object which I looked at as I would look at any other object; yet not quite, not like any other object, differently, like something that was dead and alive at the same time. I let out a cry of terror as if I had just crossed over a threshold, as if I had gone into a world that nobody had seen before. All the living were dead, and this vision came back often, in the metro, in the street, in restaurants or with friends. That waiter at the Brasserie Lipp who stood motionless, bending over me, his mouth open, with no connection with the previous moment or with the following moment, his mouth open, his eyes fixed and unwavering. And at the same time as people, objects underwent a transformation: tables, chairs, clothes, streets, even trees and landscapes.

When I woke up that morning I saw my towel for the first time, a weightless towel in a stillness that nobody had ever experienced before, as if suspended in a terrifying silence. It no longer had any connection with the broken chair or with the table whose legs were no longer planted on the floor, which they barely touched; there was no connection any more between these objects separated by immeasurable chasms of emptiness. I looked at my room in terror and a cold sweat ran down my back.

A few days after I had written the above in a single session, I wanted to get back into the story and rework it. I was in a café on the boulevard Barbès-Rochechouart where the prostitutes have strangely long, thin, tapering legs.

A feeling of boredom and antagonism stopped me from rereading myself, but despite that I started to describe my dream differently. I tried to describe what had struck me more accurately and more vividly: the volume and density of the brown spider, for example, the thickness of its coat which looked as if it might be agreeable to touch, the position and exact shape of its web, the expected and feared arrival of the yellow spider, and above all the shapes of its scales, like flat, sliding waves, the strange makeup of its head and the sharpness of its extended right foot. But I wanted to describe all this in a purely emotive way, giving certain points a hallucinatory quality without looking for any connection between them.

I lost heart after a few lines and stopped.

Some black soldiers walked past outside in the fog, the same fog that had already filled me with a curious sense of pleasure the day before.

There was a contradiction between the emotive way of conveying

what I had found hallucinating and the sequence of facts that I wanted to describe. I was faced with a confused mass of times, events, places and sensations.

I tried to find an acceptable solution.

First I attempted to indicate each fact by a couple of words which I put in a vertical column on the page; this came to nothing. I tried drawing some little boxes, again vertically, which I would have filled in bit by bit, in an attempt to put all the facts simultaneously on the page. But the time sequence got muddled, so I tried to put everything down chronologically. I kept coming up against the tubular form of narrative which I disliked. In my story time went mostly backwards, from the present to the past, but with the odd twist and ramification. In the first version, for instance, I couldn't find a way of including the lunch with RM[4] at noon on Saturday, before my visit to the doctor.

I told RM my dream, but when I got to the point where I was burying the remains I saw myself in another field surrounded by thickets at the edge of a forest. Having pushed the snow away with my feet and dug a hole in the hardened soil, I buried a barely nibbled loaf of bread (the bread stolen when I was a child) and I saw myself once again running through Venice, with my hand clutching a piece of bread that I wanted to get rid of. I went from one end of Venice to the other looking for lonely, out-of-the-way spots and at last, after several attempts on the remotest little bridges beside the murkiest canals had failed, I threw the bread with a nervous shudder into the stagnant water in the last reach of a canal surrounded by black walls; then I ran off, terrified and barely conscious of what I was doing. That led me to describe the state I was in at that time: to talk about the trip to the Tyrol, Van M's death*[5] (that long rainy day when I sat in front of a bed in an hotel room, with Maupassant's book on Flaubert in my hand) I saw Van M's head being transformed (his nose more and more prominent, his cheeks more sunken and his almost motionless open mouth barely breathing, and when I tried to draw his profile towards evening I was suddenly overcome by the fear that he was going to die), the stay in Rome the previous summer (the newspaper I chanced on that carried the advertisement trying to find me), the train to Pompeii, the temple at Paestum.

But also the scale of the temple and the scale created by a man standing between its columns. The man appearing between the columns becomes a giant, the temple grows no smaller, so measuring in metres no longer works, contrary to what happens at St Peter's in Rome, for example. In that church, when it is empty, the interior seems small (you can see that on photographs) but men look like

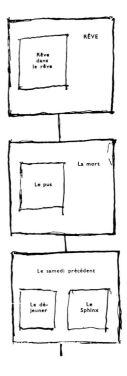

ants and St Peter's does not get bigger; there only metric measurement works.

That led to talking about the scale of heads, the scale of objects and the connections and differences between objects and living beings, and that was how I got to what was uppermost in my mind, at the very moment that I was telling this story at noon on Saturday.

I thought all this over as I sat in the café on the Boulevard Barbès-Rochechouart and searched for a way of expressing it. Suddenly I had the feeling that all these events existed simultaneously around me. Time became horizontal and circular, became space at the same time, and I tried to draw it.

Shortly afterwards I left the café.

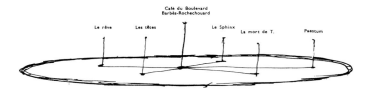

This horizontal disk filled me with pleasure and as I walked along I saw it almost simultaneously in two different ways. I saw it drawn vertically on a page.

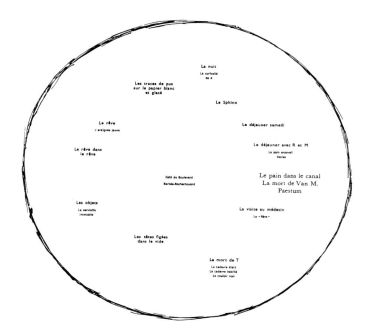

But I was keen on having it horizontal, I did not want to lose that, and I saw the disk turn into an object.

It was a disk about two metres in radius and divided into segments by lines. Each segment carried the name, the date and the place of the event which corresponded to it, and on the edge of the circle there was a panel in front of each segment. The panels were of varying widths and separated by an empty space.

Each panel bore the story concerning its particular segment. I took a curious pleasure imagining myself walking on this space-time disk reading the stories that were in front of me, having the freedom to start wherever I wanted, to begin for instance with the dream of October 1946 and, after going the whole way round, to end up several months earlier looking at the objects, looking at my towel. I was particularly concerned with the place each fact would occupy on the disk.

But the panels are still empty. I do not know enough about the meaning of words or the way they work together to fill them in.

1 The Sphinx was a well-known brothel in Montparnasse which Giacometti frequented.
2 T. refers to Tonio Pototsching, who acted as concierge for the building where Giacometti had his studio and whose death the artist witnessed.
3 A. stands for Annette Arm, who had recently joined Giacometti in Paris and whom he married in 1949.
4 RM is the painter Roger Montandon.
5 Van M., mentioned in the footnote, refers to Peter Van Meurs, an elderly Dutchman who, in 1921, invited Giacometti to travel with him through the Alps to Venice and who died during the trip in the young artist's presence.

Originally published in *Labyrinthe*, no. 22/23, December, 1946.
Extract from *Alberto Giacometti, Ecrits*, © Hermann, Paris, 1991.

MY REALITY*

Alberto Giacometti

From the very beginning, from the first moment I drew or painted, I have certainly been painting and sculpting to get a grip on reality, to protect myself, to feed myself, to get bigger; to get bigger to protect myself better, to fight better, to keep going, to move forward as far as I can on every front, in every direction, to protect myself against hunger, against the cold, against death, to be as free as possible; as free as possible to try — with the means that are now most clearly mine — to see better, to understand things around me better, to understand better to be as free and as big as possible, to spend, to spend myself as much as possible in what I do, to discover new worlds, to wage my war, for pleasure? For joy? War for the pleasure of winning and losing.

* Reply to a questionnaire entitled *A chacun sa réalité* (To Each His Own Reality) sent out by Pierre Volboudt, to which seventeen artists responded. Originally published in *XXme Siècle*, no. 9, June 1957. Extract from *Alberto Giacometti, Ecrits*, © Hermann, Paris, 1991.

ALL THAT IS NOT SO VERY MUCH

Alberto Giacometti

All that is not so very much,
all the painting, sculpture,
drawing, writing or rather literature.
All that has its place
and nothing more.

Trying is everything,
how marvellous!

Published posthumously in *L'Ephémère*, no. 1, Winter, 1966.
Extract from *Alberto Giacometti, Ecrits*, © Hermann, Paris, 1991.

CATALOGUE

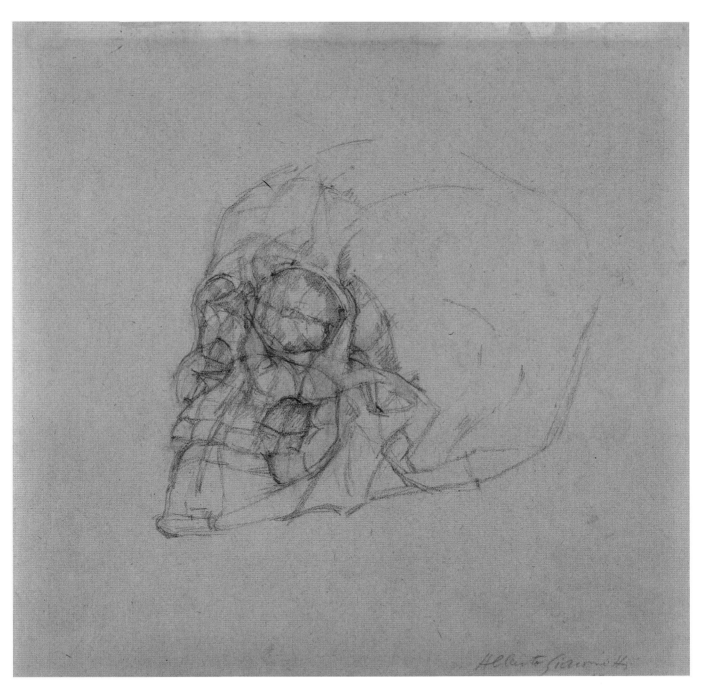

1 *The Skull*, 1923. Pencil on paper, 22.9 × 21.6 cm. Robert and Lisa Sainsbury Collection, University of East Anglia.

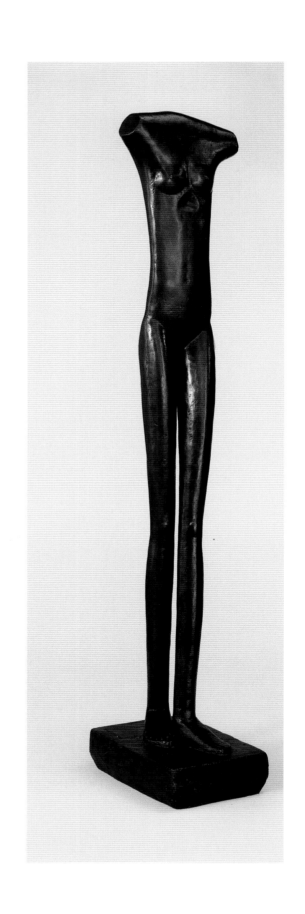

2 *Walking Woman*, 1932–36.
Bronze, 149.9 × 27.6 × 37.8 cm.
Tate. Presented by the artist
and Mrs Erica Brausen, 1972.

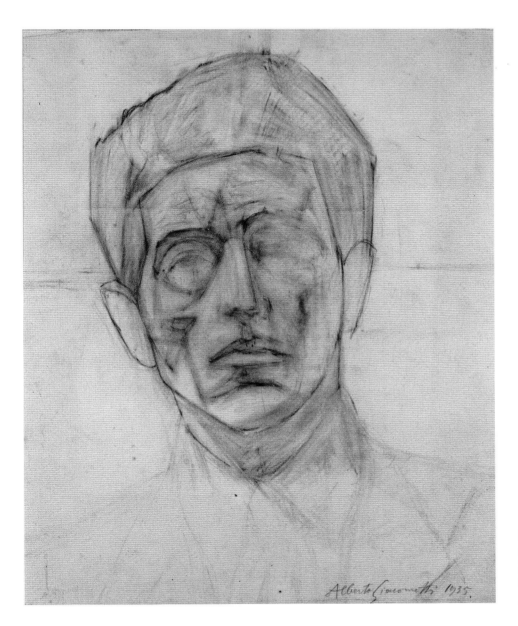

3 *Self-portrait*, 1935. Pencil on Cardboard, 30.2 × 24.1 cm. Robert and Lisa Sainsbury Collection, University of East Anglia.

4 *Still-life*, 1935–36. Bronze,
49.5 × 69.5 cm. Annette
Giacometti Estate.

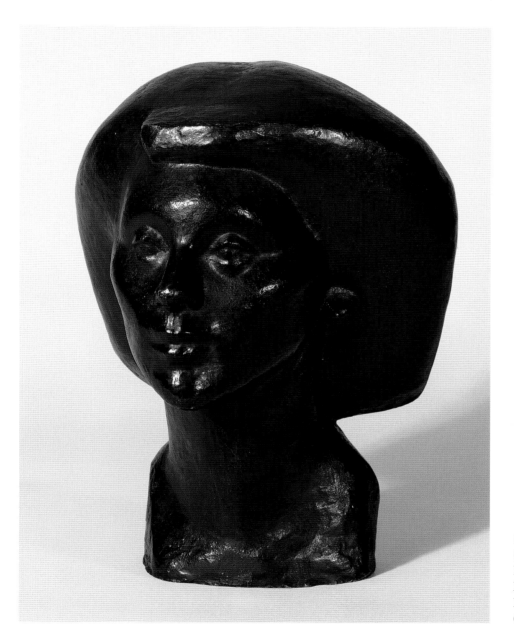

5 *Bust of Isabel Rawsthorne*
(*Tête Egyptienne*), 1938–39.
Bronze, 29.1 × 21.8 × 24.4 cm.
Lent by the Syndics of the
Fitzwilliam Museum,
Cambridge.

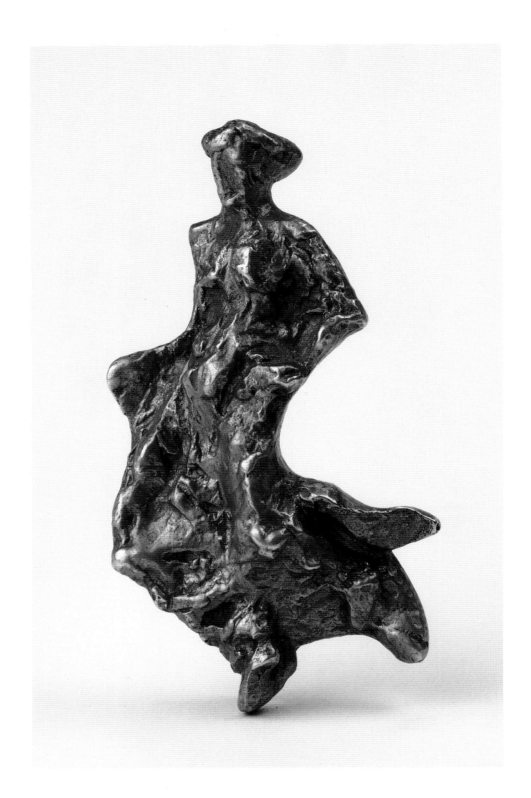

6 *Brooch as a Draped Female
Figure*, 1937–38. Gilt bronze,
9.2 × 5.2 × 1.5 cm. Robert and
Lisa Sainsbury Collection,
University of East Anglia.

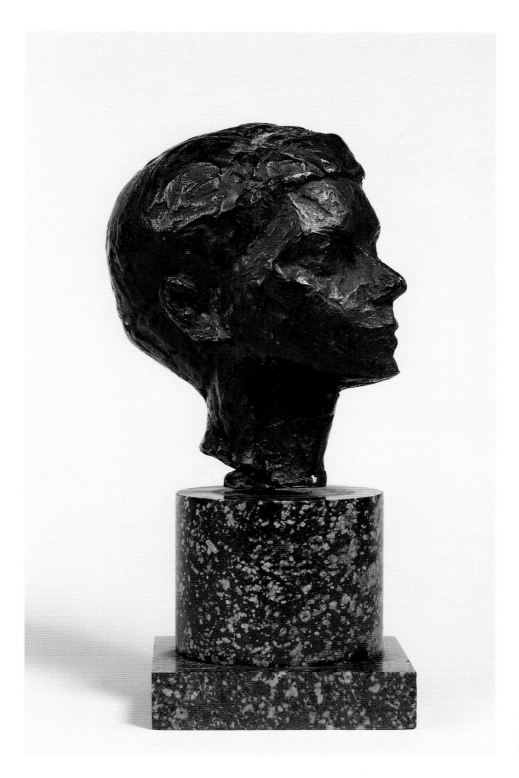

7 *Head of Rita*, 1938. Bronze,
h. 8.3 cm. Robert and Lisa
Sainsbury Collection.

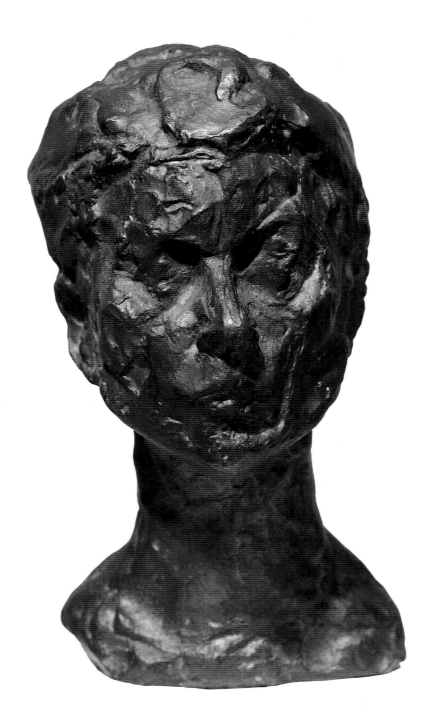

8 *Rita*, 1938. Bronze, 22 × 13.5
× 16 cm. Kunsthaus Zürich,
Gift of Bruno Giacometti to the
Vereinigung Zürcher
Kunstfreunde.

9 Facing page: *Head of Isabel
II* (*Isabel Rawsthorne*),
1938–39. Bronze, 21 × 18 cm.
Robert and Lisa Sainsbury
Collection, University of East
Anglia.

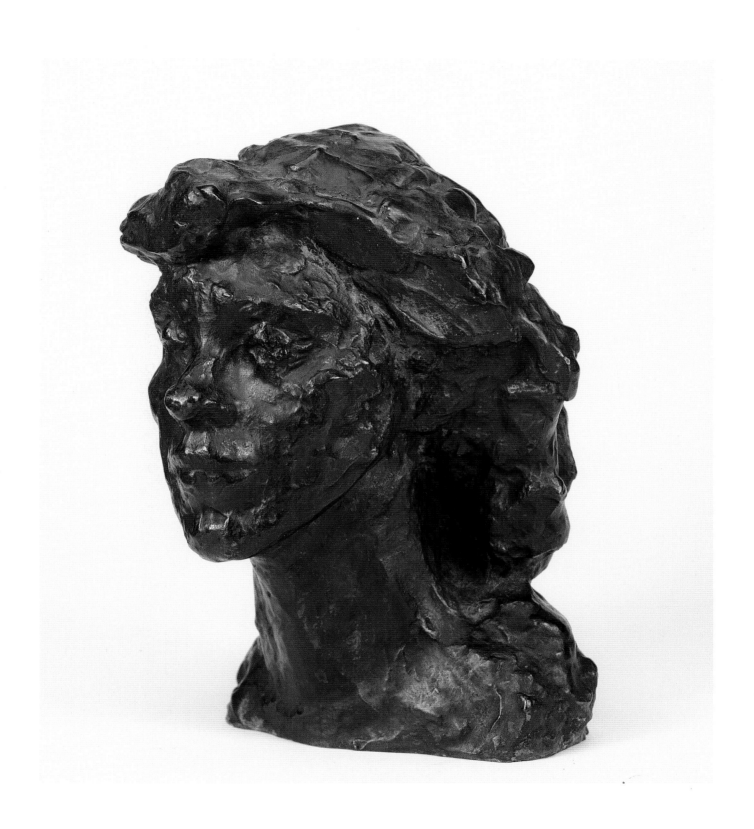

10a *Isabel* (Rawsthorne)
Reclining, 1940 (Verso). Pencil
on paper, 30.5 × 47.5 cm. Robert
and Lisa Sainsbury Collection,
University of East Anglia.

10b *Isabel* (Rawsthorne)
Reclining, 1940 (Recto). Pencil
on paper, 30.5 × 47.5 cm. Robert
and Lisa Sainsbury Collection,
University of East Anglia.

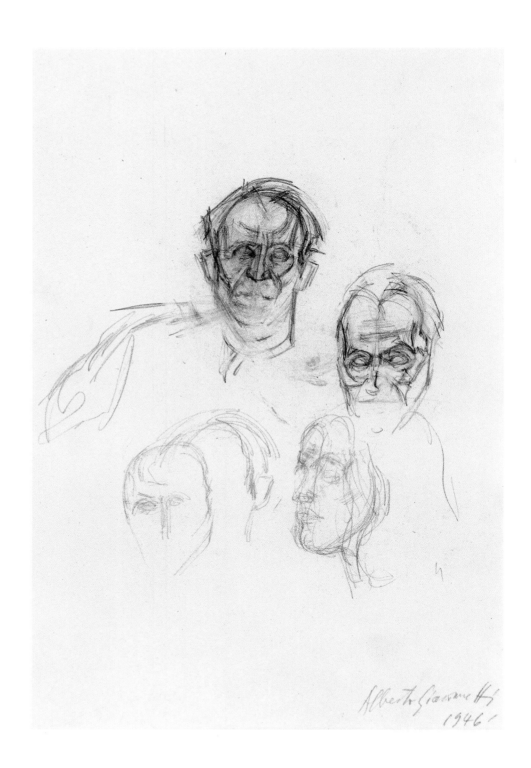

11 *Study of Heads*, 1946.
Pencil on paper, 37 × 26.5 cm.
Paule and Adrien Maeght
Collection, Paris.

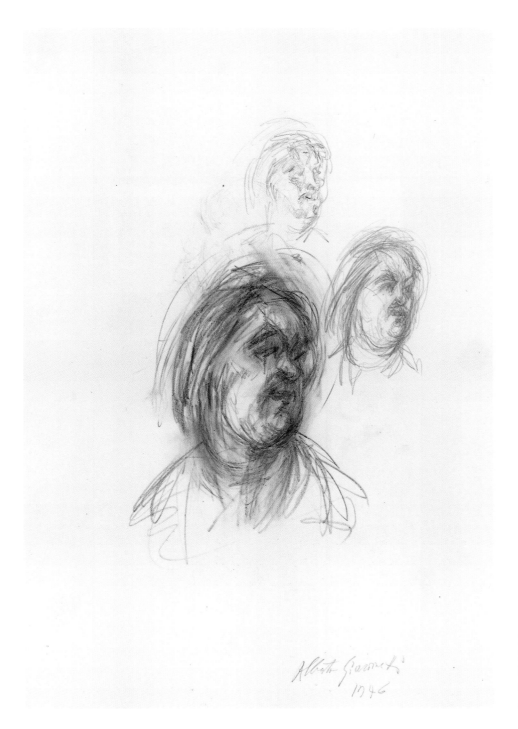

12 *Homage to Balzac*, 1946.
Pencil on paper, 45.4 × 30.5 cm.
Robert and Lisa Sainsbury
Collection, University of East
Anglia.

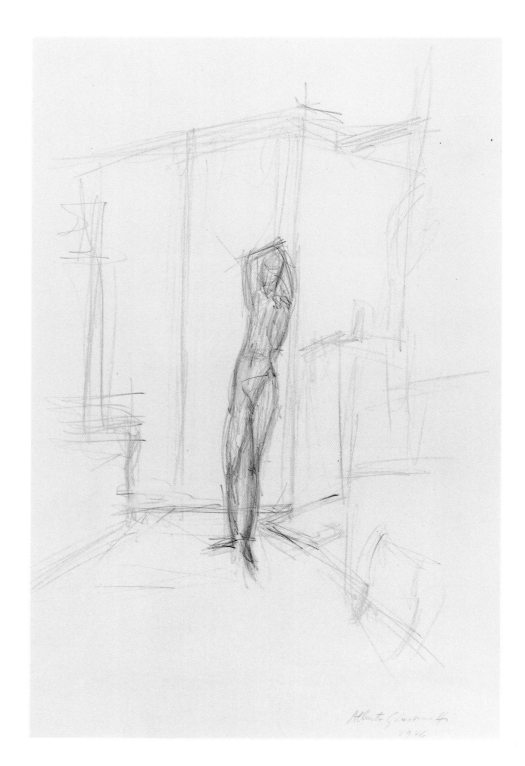

13 *Standing Figure*, 1946.
Pencil on paper, 52.1 × 34.3 cm.
Robert and Lisa Sainsbury
Collection, University of East
Anglia.

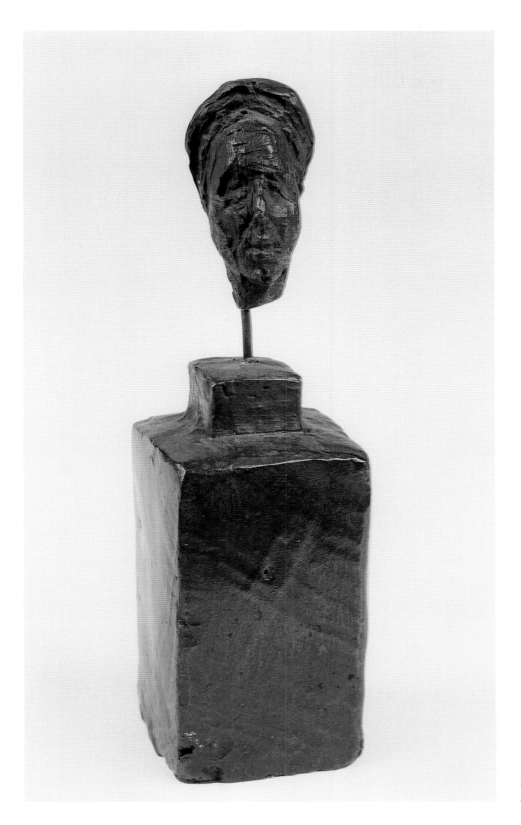

14 *Simone de Beauvoir*, 1946.
Bronze, h. 13.5 × 4 × 4 cm.
Annette Giacometti Estate.

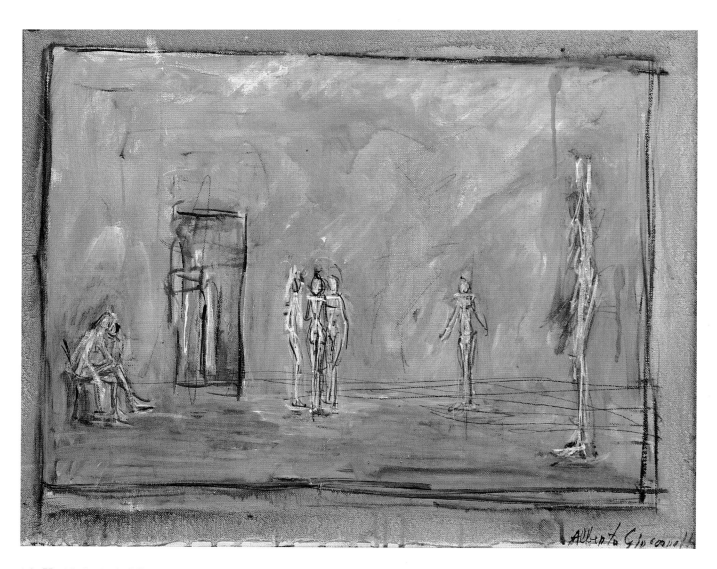

15 *Untitled*, 1946. Oil on
canvas, 33 × 41 cm.
Private collection.

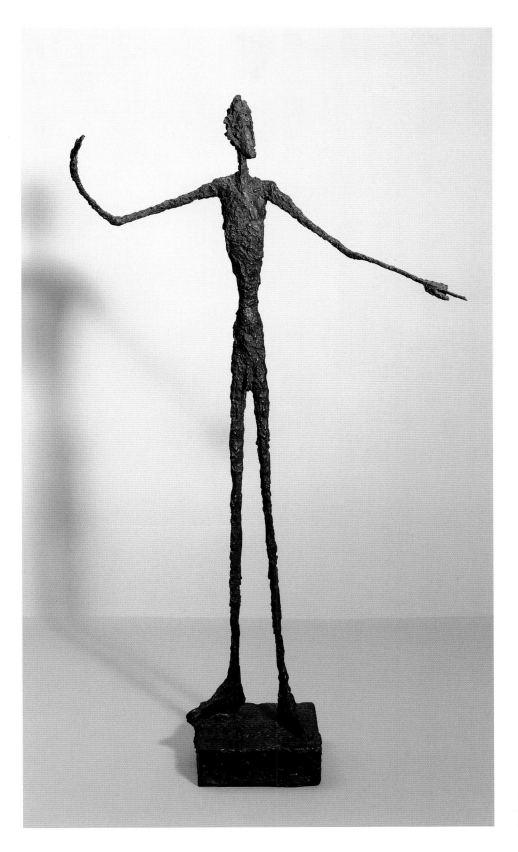

16 *Man Pointing*, 1947. Bronze, 178 × 95 × 52 cm. Tate. Purchased 1949.

17 *Head of a Woman*, 1947.
Pencil on paper, 48.3 × 30.5 cm.
Robert and Lisa Sainsbury
Collection, University of East
Anglia.

18 *Seated Woman*, 1947. Pencil
on paper, 48.3 × 30.5 cm. Robert
and Lisa Sainsbury Collection,
University of East Anglia.

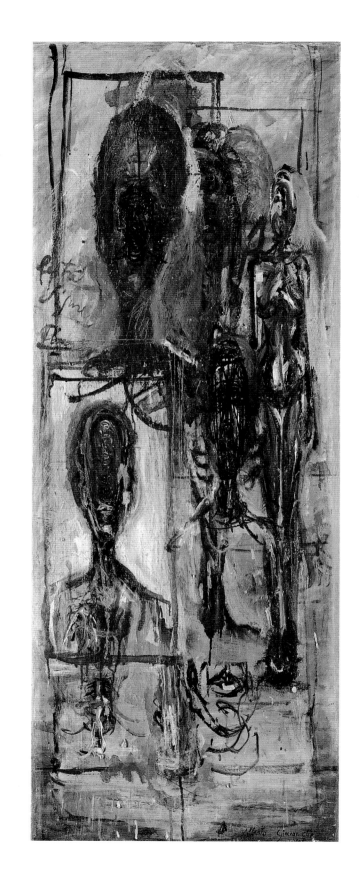

19 *Studies for Sculpture*, 1947.
Oil on canvas, 110 × 40 cm.
Paul Büchi Foundation,
Switzerland.

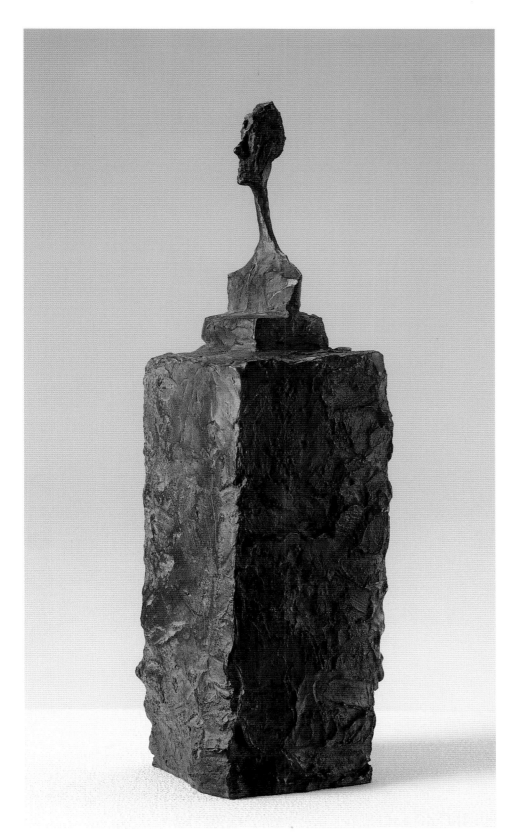

20 *Small Bust on High Plinth,*
(*Diego*) 1947. Bronze, h. 37.5 cm.
Private collection

21 *Untitled (Giacometti)*, 1948.
Pencil on paper, 29.5 × 24.5 cm.
Paule and Adrien Maeght
Collection, Paris.

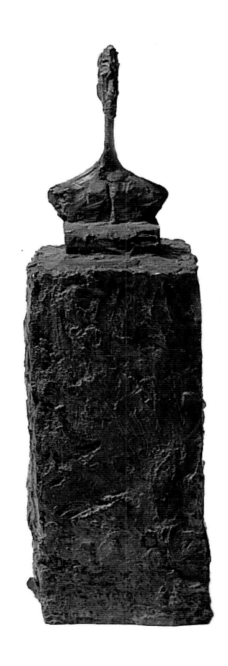

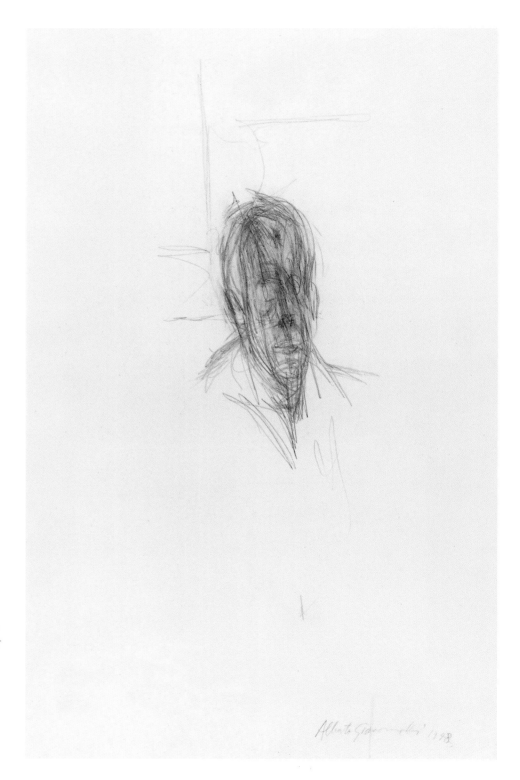

23 *Portrait of the Artist's Brother*, 1948. Pencil on paper, 49.2 × 30.5 cm. Robert and Lisa Sainsbury Collection, University of East Anglia.

24 Facing page: *Diego Seated*, 1948. Oil on canvas, 80.6 × 50.2 cm. Robert and Lisa Sainsbury Collection, University of East Anglia.

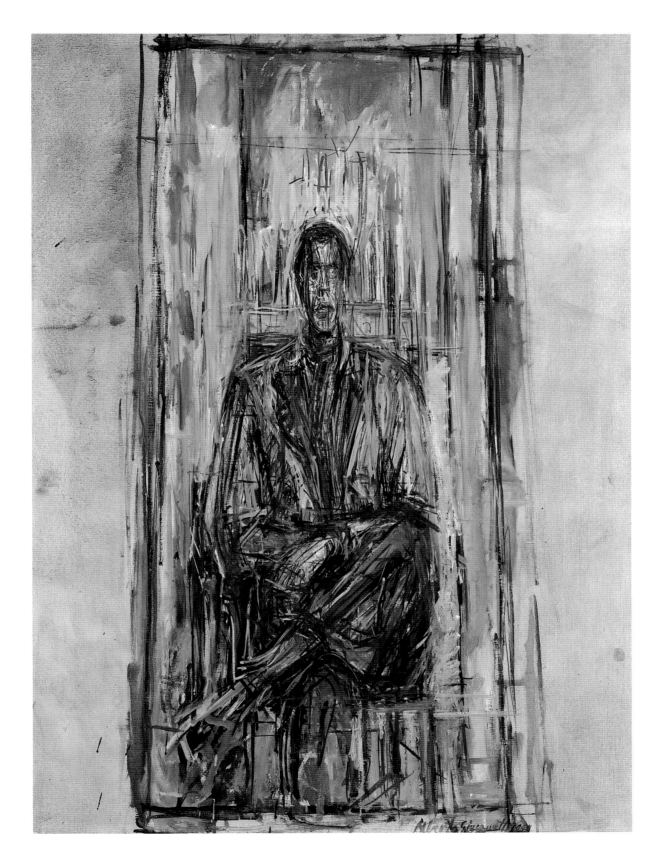

25 *The Tree*, 1949. Pencil on paper, 33.3 × 24.8 cm. Robert and Lisa Sainsbury Collection, University of East Anglia.

26 *Still Life*, 1949. Pencil on
paper, 36.8 × 52.1 cm. Robert
and Lisa Sainsbury Collection,
University of East Anglia.

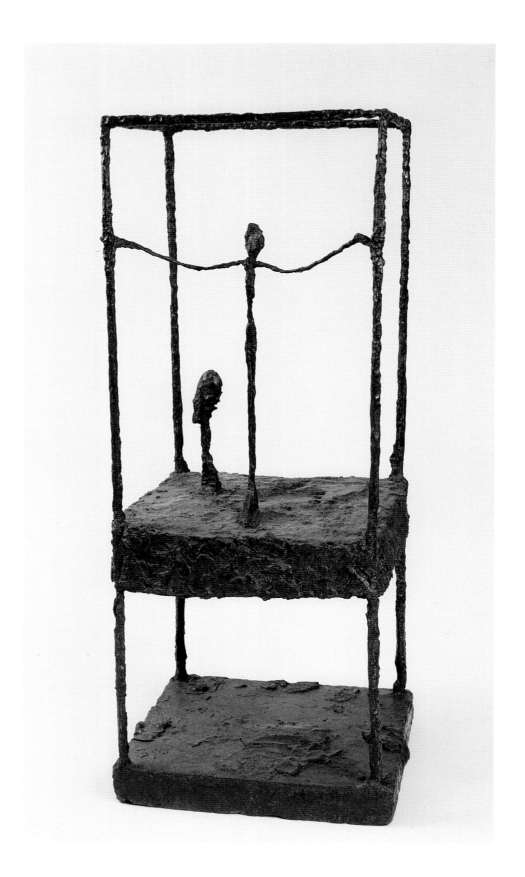

27 *The Cage, First Version*,
1950. Bronze, h. 90.5 cm.
Annette Giacometti Estate.

28 Facing page: *Portrait of the
Artist's Mother (Annetta)*,
1949–50. Oil on canvas, 68.5 ×
62 cm. Private collection,
Courtesy Art Focus, Zürich.

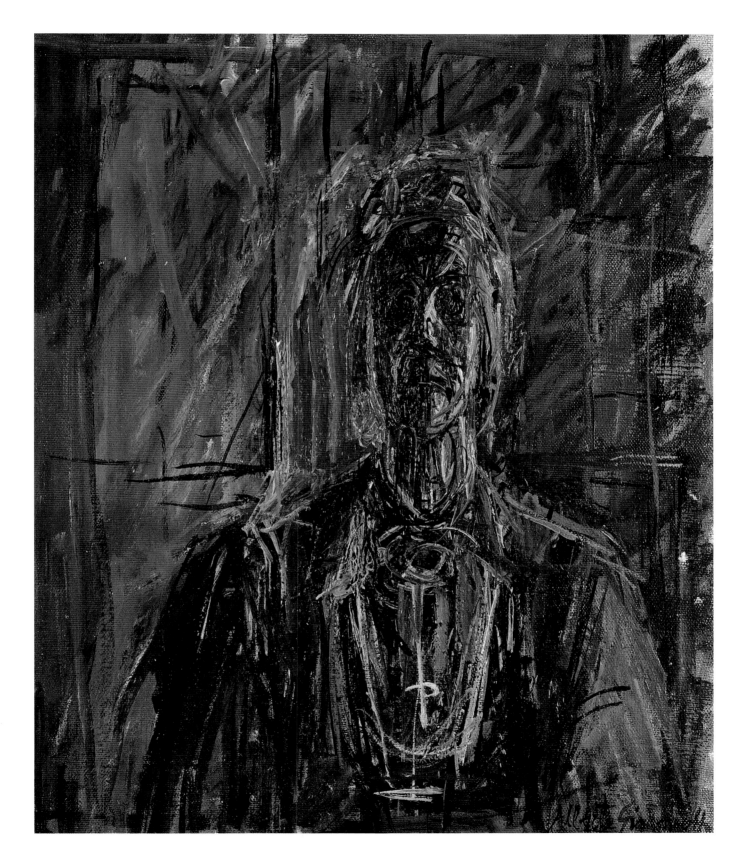

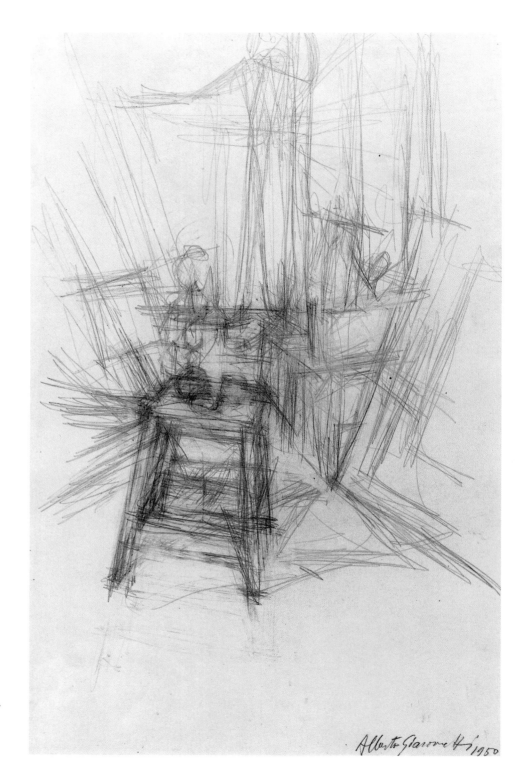

29 *Table in a Room*, 1950.
Pencil on paper, 47.6 × 29.8 cm.
Robert and Lisa Sainsbury
Collection, University of East
Anglia.

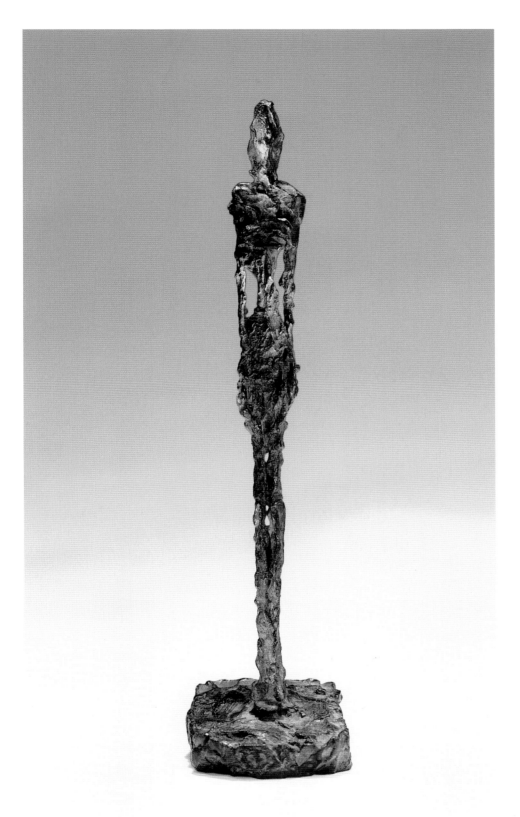

30 *Standing Woman*, 1950.
Bronze, 30.3 × 7.1 × 9.6 cm.
Private collection, Courtesy
Pieter Coray.

31 *The Tree*, 1950. Pencil on
paper, 50.5 × 34.9 cm. Robert
and Lisa Sainsbury Collection,
University of East Anglia.

32 *Cavalier*, 1950. Pencil on
paper, 34.9 × 47.6 cm. Robert
and Lisa Sainsbury Collection,
University of East Anglia.

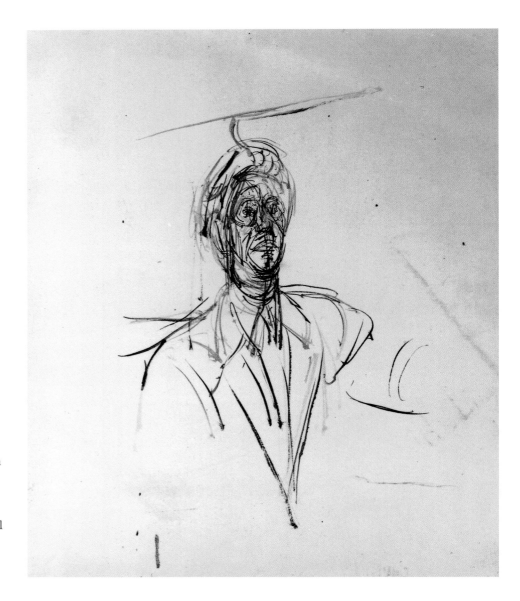

33 *Self-portrait*, 1950. Pencil on paper, 56.5 × 47 cm. Private collection.

34 Facing page: *Diego*, 1950. Oil on canvas, 80 × 58.4 cm. Robert and Lisa Sainsbury Collection, University of East Anglia.

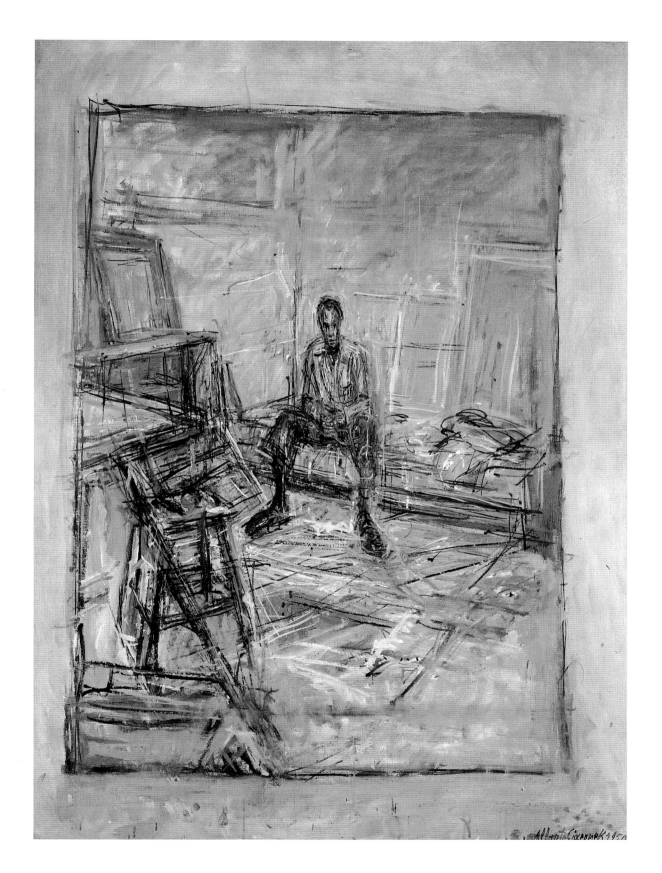

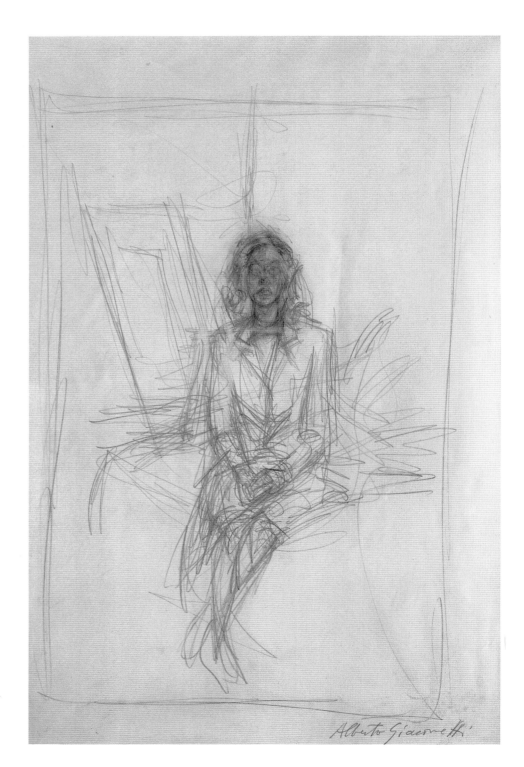

35 *Annette Sitting*, 1950. Pencil on paper, 49 × 31 cm. Private collection, Courtesy Art Focus, Zürich.

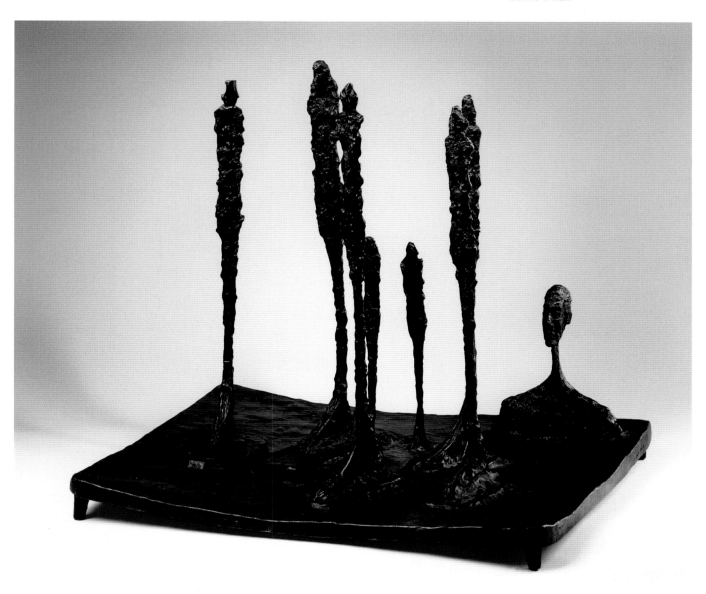

36 *The Forest*, 1950. Bronze, 57 × 61 × 49.5 cm. Fondation Marguerite et Aimé Maeght, Saint-Paul.

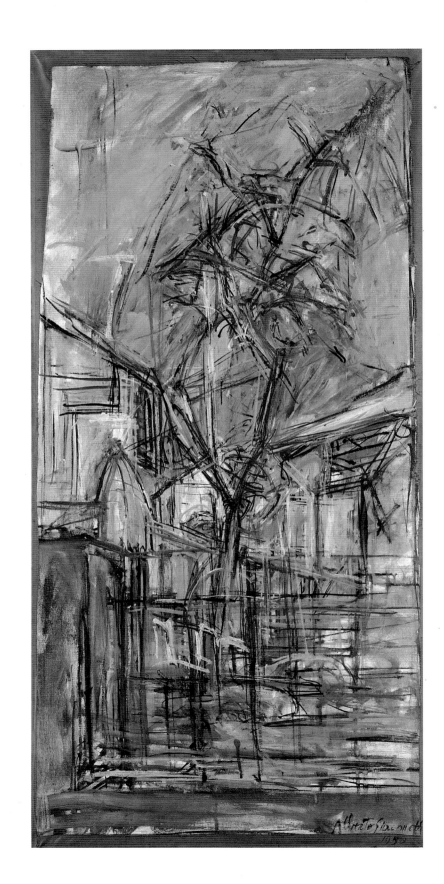

37 *The Tree*, 1950. Oil on canvas, 78.7 × 36.1 cm. Robert and Lisa Sainsbury Collection, University of East Anglia.

38 Facing page: *Still Life with Flowers*, 1952. Oil on canvas, 41 × 35 cm. Paule and Adrien Maeght Collection, Paris.

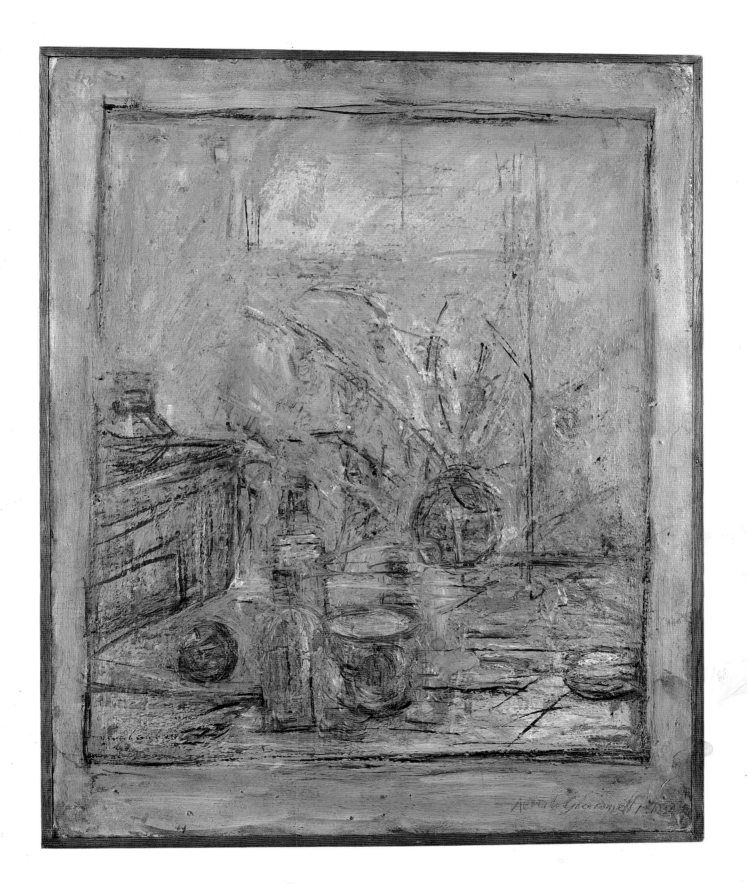

39 *Woman Working under
Light*, 1953. Pencil on paper, 50
× 35 cm. Private collection,
Courtesy Pieter Coray.

40 Facing page: *Little
Sculpture*, 1953. Oil on canvas,
81 × 65 cm. Private collection.

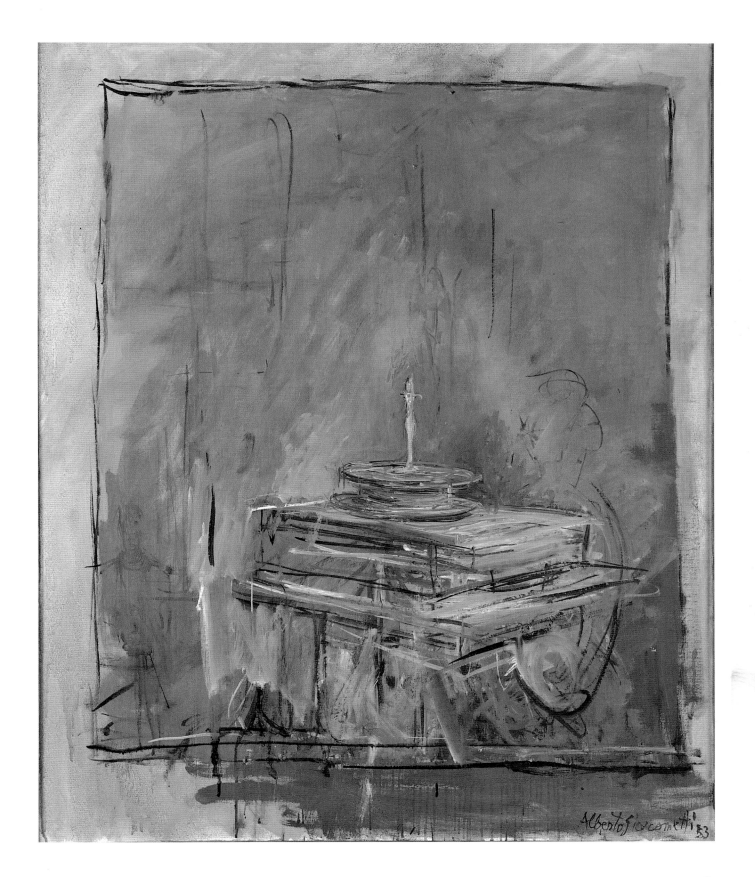

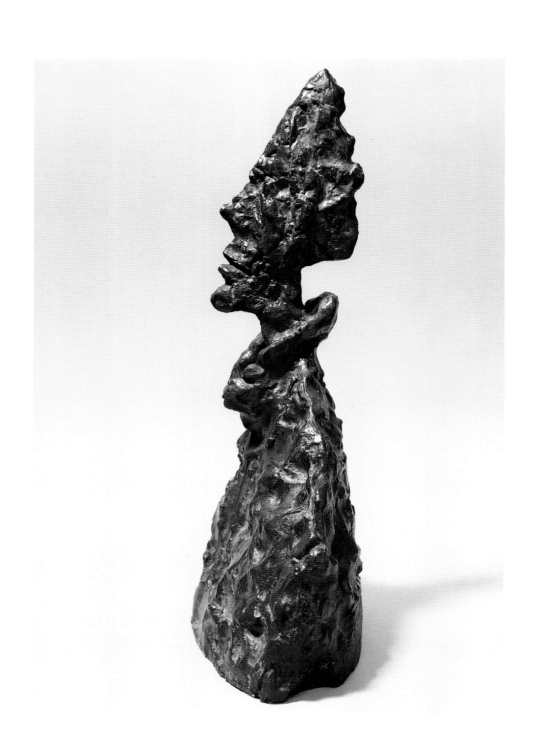

41 *Diego au Blouson*, 1953.
Bronze, 35.5 × 28 × 10.5 cm.
Kunsthaus, Zürich.

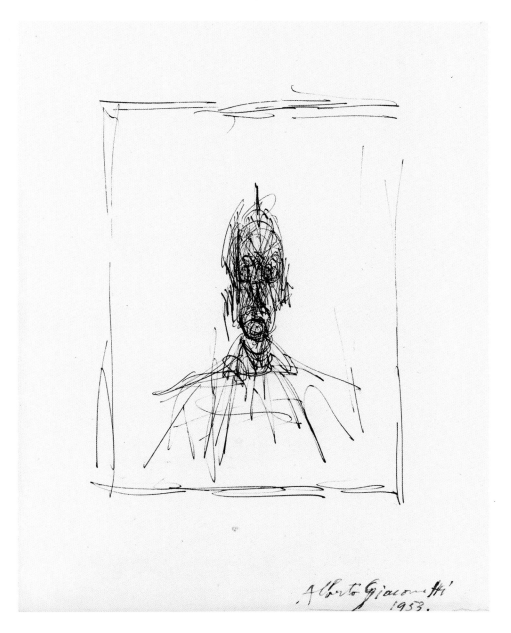

42 *Portrait of a Man*, 1953. Ink on paper, 30 × 24.5 cm. Private collection.

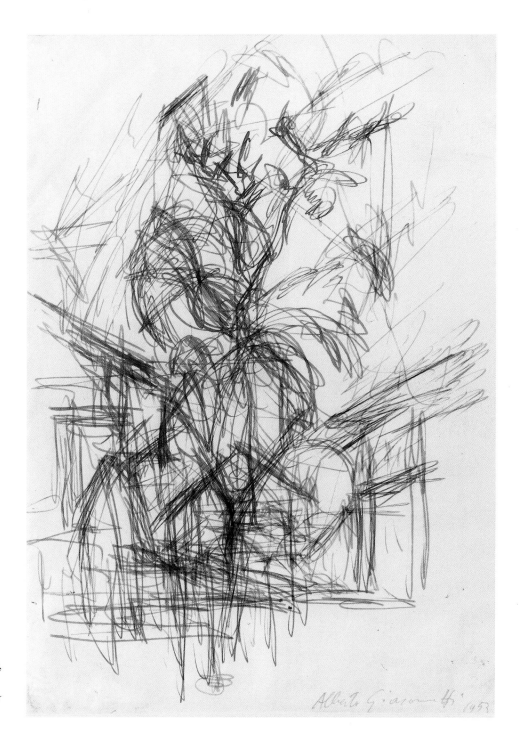

43 *The Tree*, 1953. Ink on paper,
27.6 × 19.1 cm. Robert and Lisa
Sainsbury Collection, University
of East Anglia.

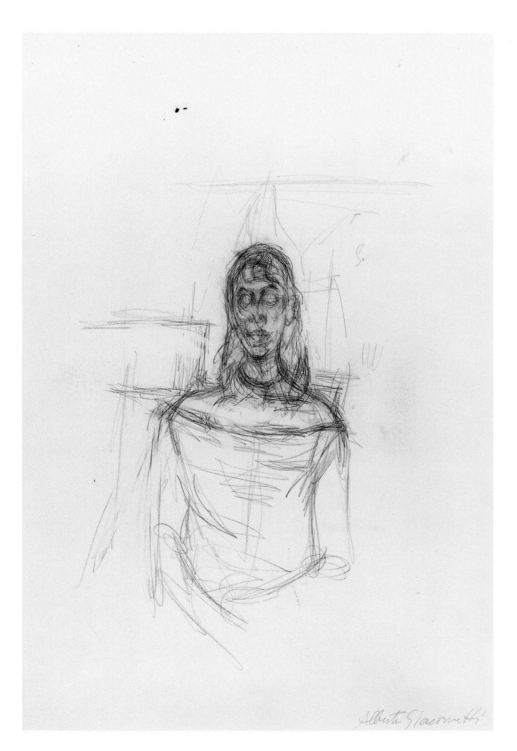

44 *Seated Woman, Annette,*
*c.*1954. Pencil on paper, 48.6 ×
31.8 cm. Robert and Lisa
Sainsbury Collection, University
of East Anglia.

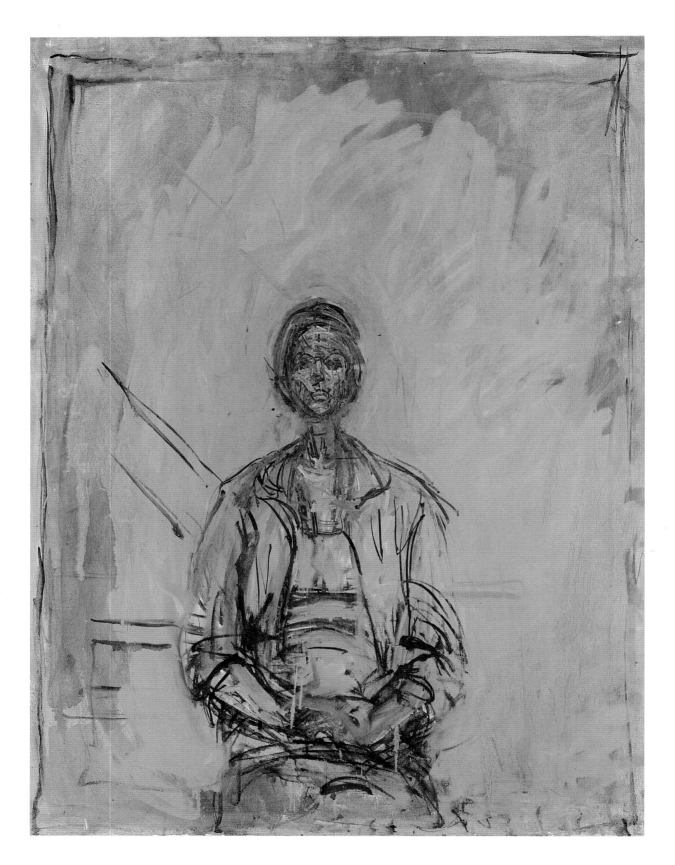

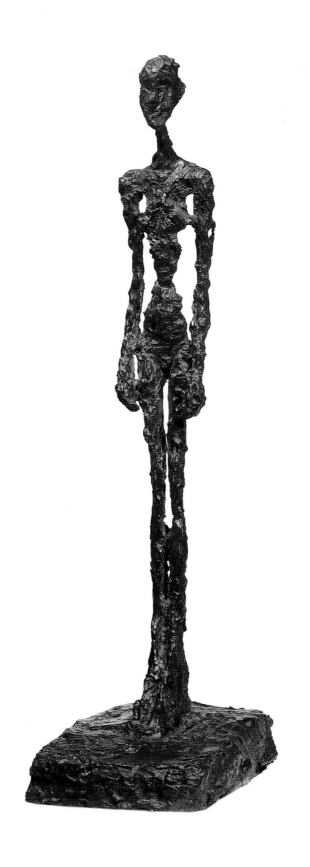

45 *Annette*, 1954. Oil on canvas, 92 × 73 cm. Annette Giacometti Estate.

46 *Standing Nude*, 1954. Bronze, 75 × 35 × 50 cm. Musée national d'art moderne, Centre Georges Pompidou, Paris.

47 Overleaf: *Bust of Diego*, 1954. Bronze, 26.7 × 20.5 × 11 cm. Private collection, Courtesy Pieter Coray.

48 Overleaf: *Bust of Diego*, 1954. Bronze, 26.7 × 20.5 × 11 cm. Fondation Marguerite et Aimé Maeght, Saint-Paul.

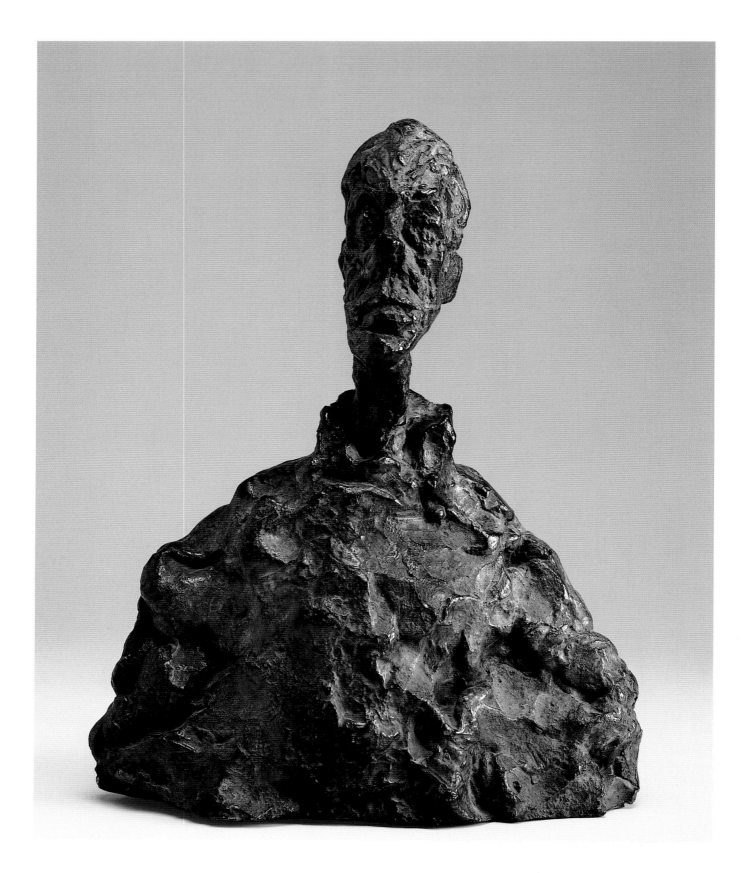

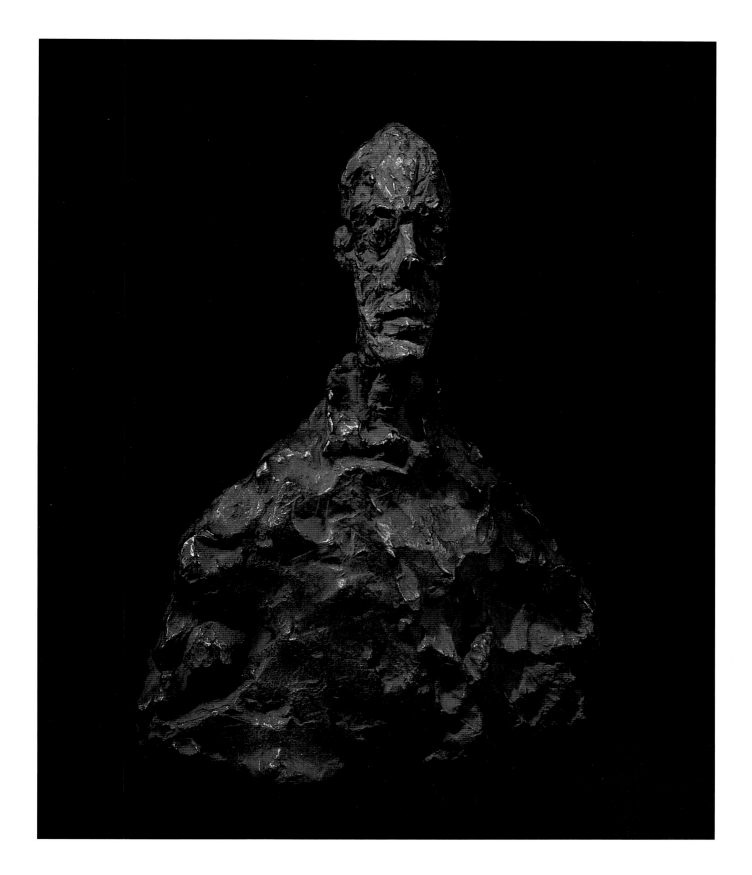

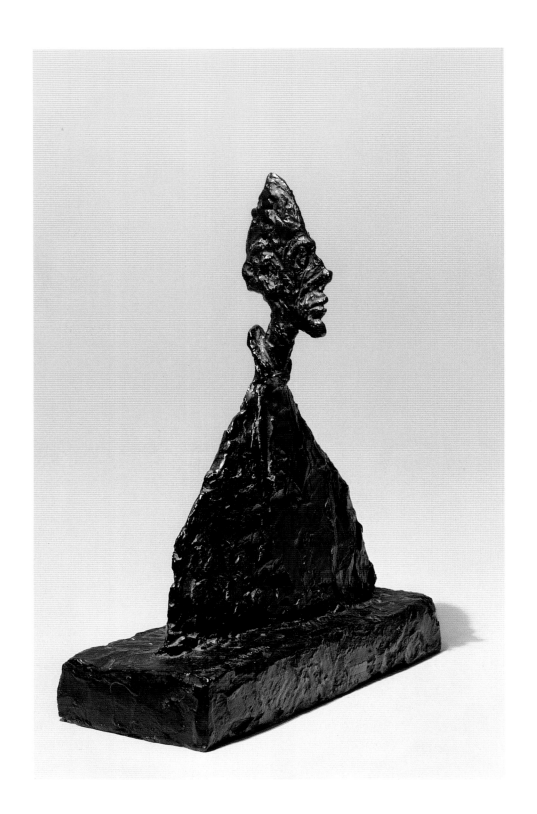

49 *Thin Bust on Plinth (Amenophis)*, 1954. Bronze, 39 × 32 × 13 cm. Private collection.

50 *Matisse*, 1954. Pencil on paper, 45 × 32 cm. Private collection.

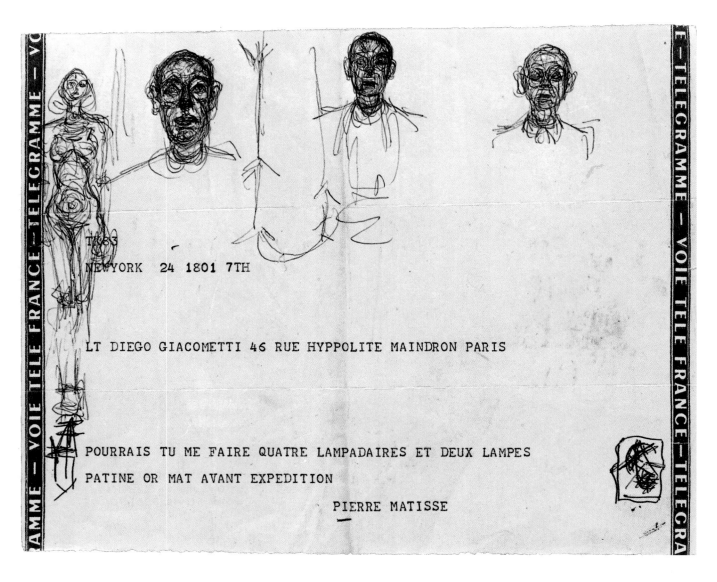

51 Above: *Telegram to Diego*,
1955–60. Pencil on paper, 16.5 ×
21 cm. Private collection.

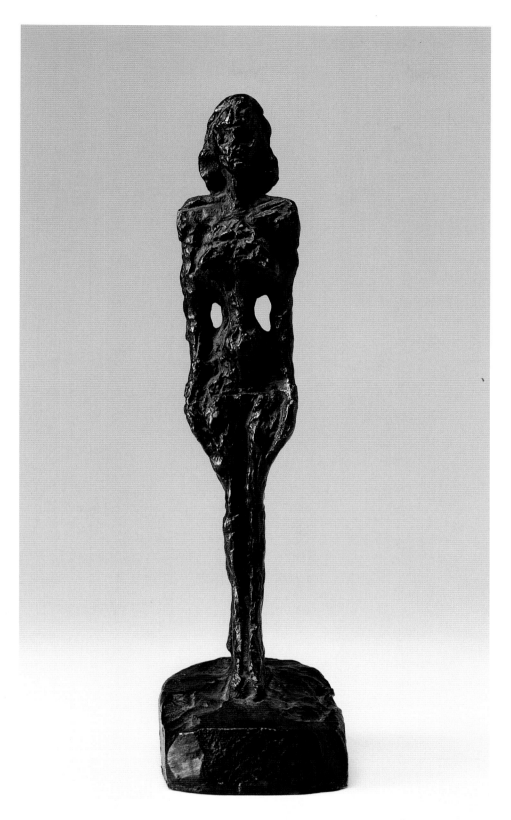

52 *Standing Nude*, 1955.
Bronze, 27 × 10 × 10 cm.
Private collection, Courtesy
Pieter Coray.

53 *Standing Nude*, 1955. Pencil
on paper, 63.8 × 48.3 cm. Robert
and Lisa Sainsbury Collection,
University of East Anglia.

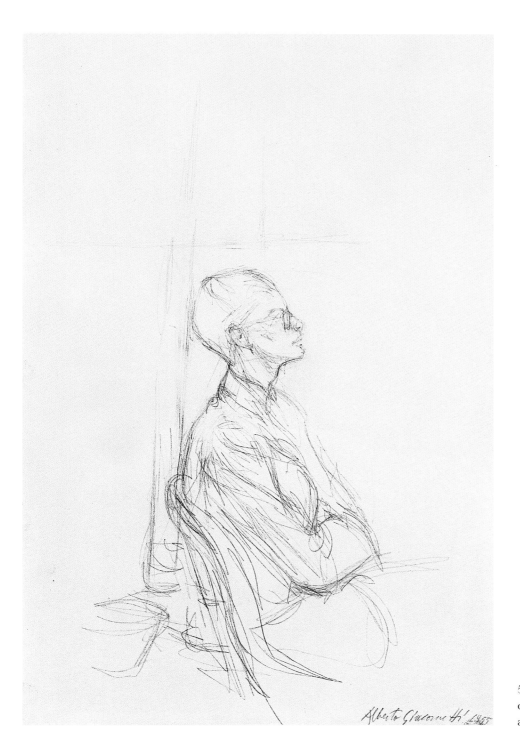

54 *David – Profile*, 1955. Pencil on paper, 47.9 × 31.4 cm. Robert and Lisa Sainsbury Collection.

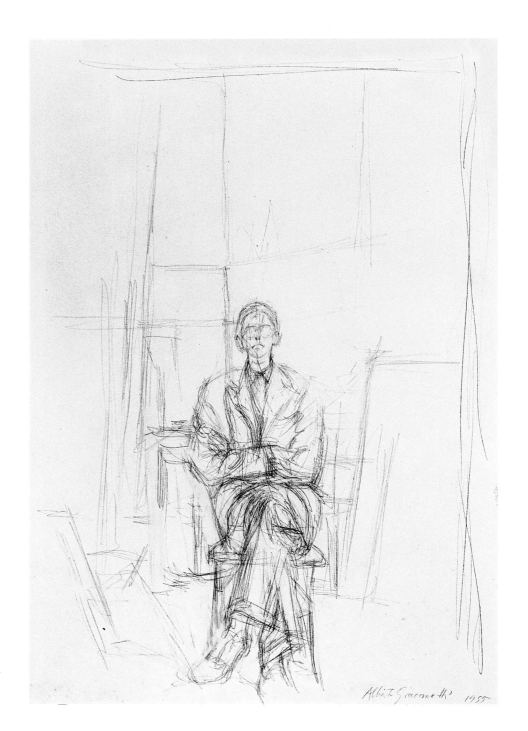

55 *David – Full Length*, 1955.
Pencil on paper, 52.2 × 37.5 cm.
Robert and Lisa Sainsbury
Collection.

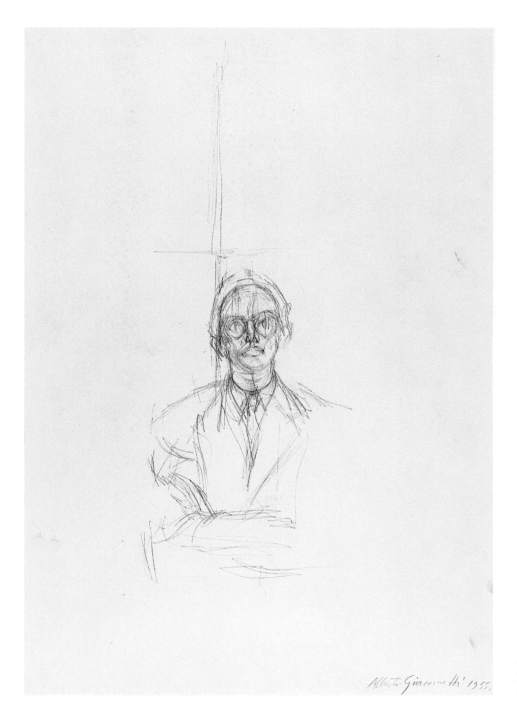

56 *David — Head and Shoulders*, 1955. Pencil on paper, 55.2 × 37.5 cm. Robert and Lisa Sainsbury Collection.

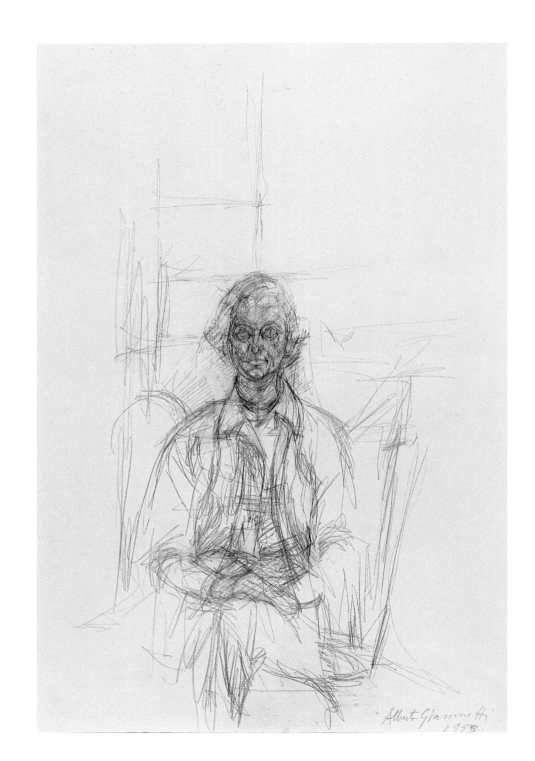

57 *Elizabeth – Head and
Shoulders 1*, 1955. Pencil on
paper, 47.9 × 31.8 cm. Robert
and Lisa Sainsbury Collection.

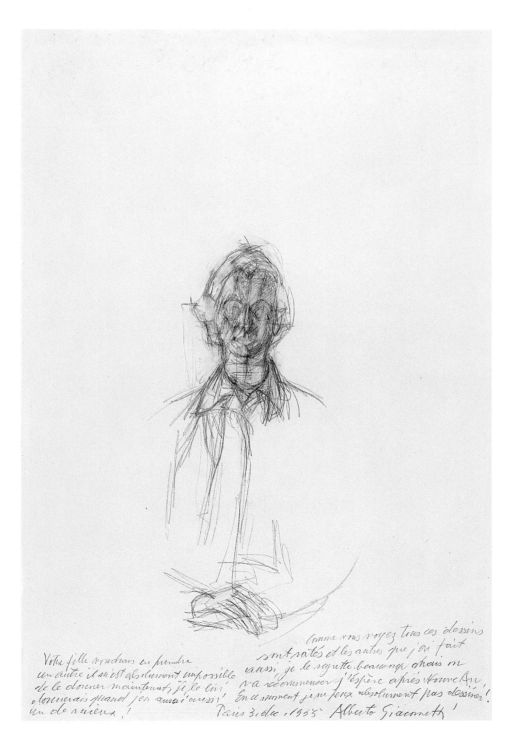

58 *Elizabeth — Head and shoulders 2*, 1955. Pencil on paper, 47.9 × 31.8 cm. Robert and Lisa Sainsbury Collection.

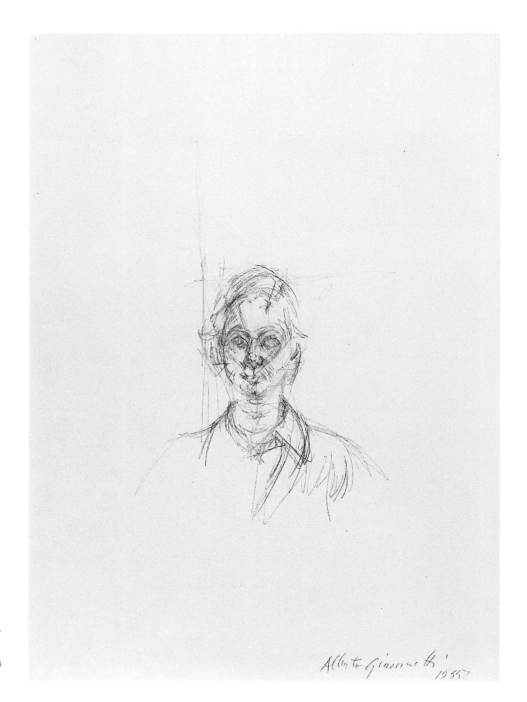

59 *Elizabeth – Head and shoulders 3*, 1955. Pencil on paper, 47.9 × 31.8 cm. Robert and Lisa Sainsbury Collection.

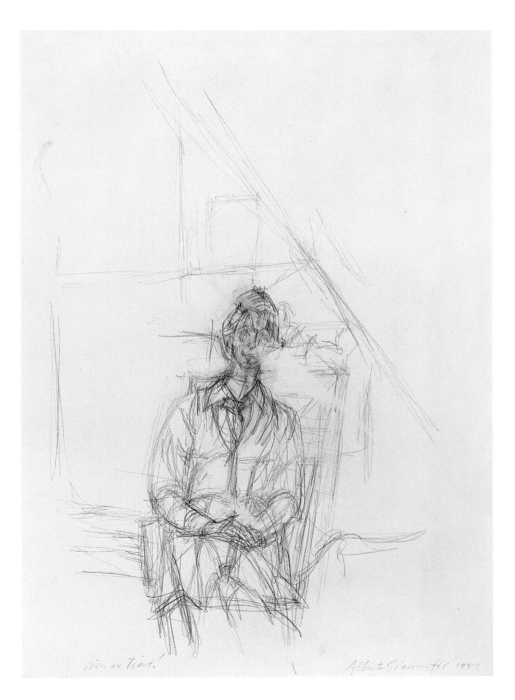

60 *Elizabeth – Head and Shoulders 4*, 1955. Pencil on paper, 55.2 × 37.5 cm. Robert and Lisa Sainsbury Collection.

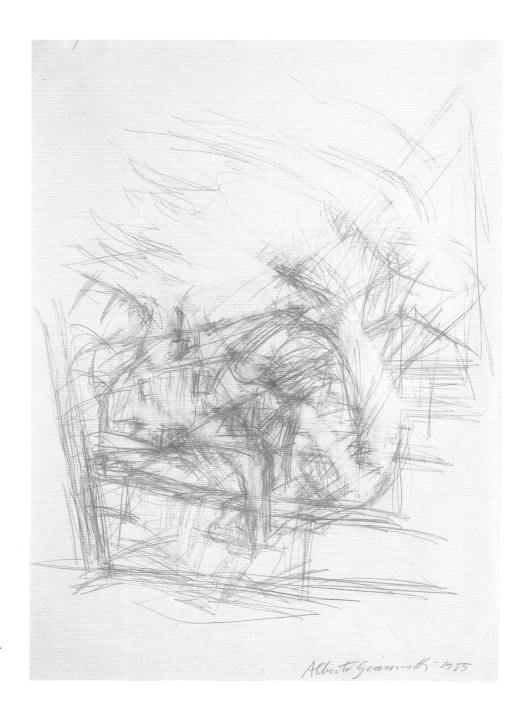

61 *Landscape (Stampa)*, 1955.
Pencil on paper, 48.5 × 34.5 cm.
Private collection, Courtesy Art
Focus, Zürich.

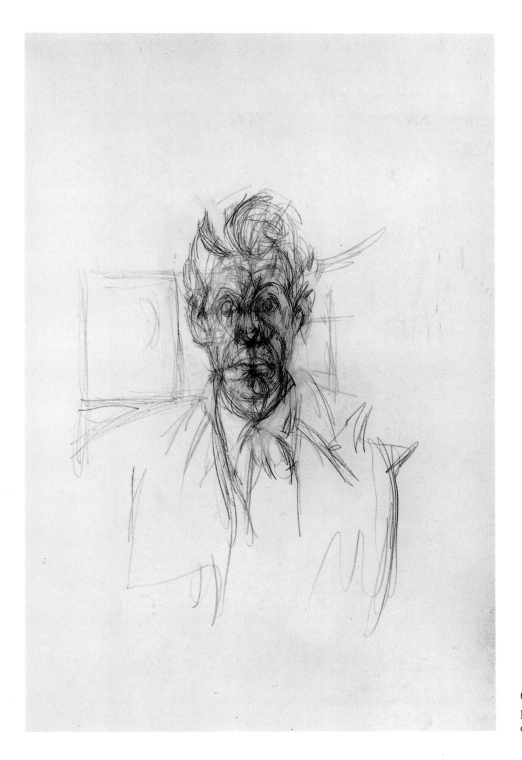

62 *Self-portrait*, 1955. Pencil on paper, 47.5 × 30.5 cm. Private collection.

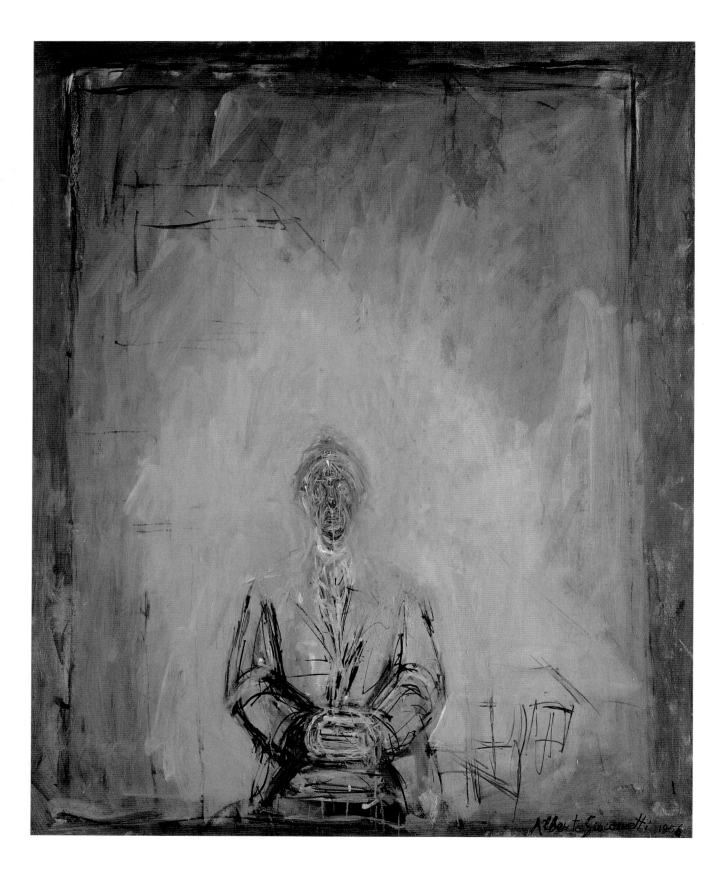

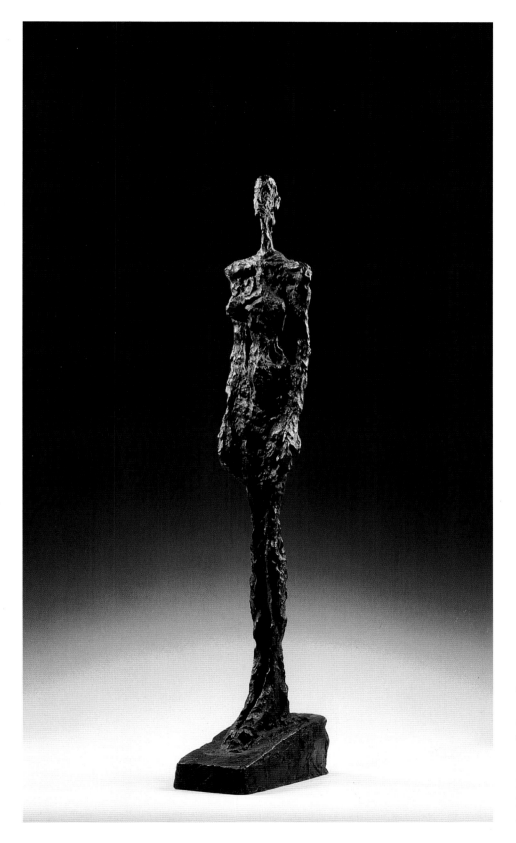

63 Previous page: *Portrait of Yanaihara*, 1956. Oil on canvas, 80 × 64.5 cm. Private collection, Courtesy Art Focus, Zurich.

64 *Venice Woman I*, 1956. Bronze, 106 × 13.5 × 29.5 cm. Fondation Marguerite et Aimé Maeght, Saint-Paul.

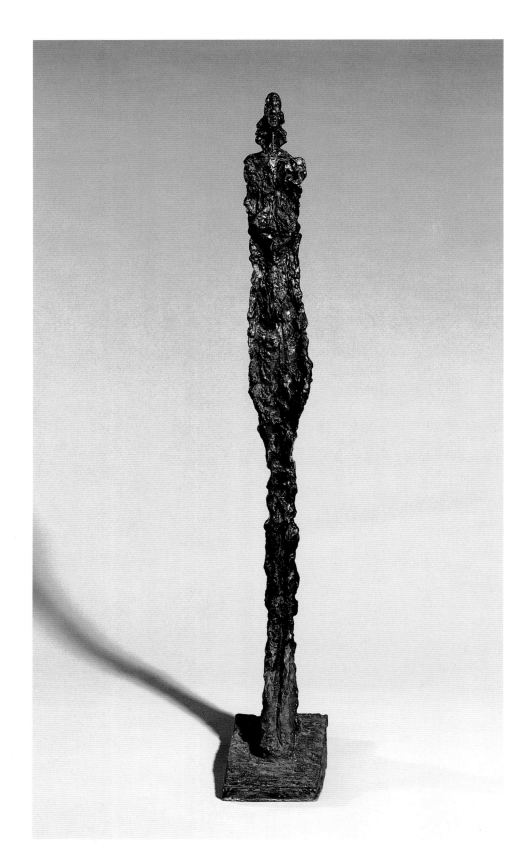

65 *Venice Woman VII*, 1956.
Bronze, 117 × 16.5 × 36.5 cm.
Fondation Marguerite et Aimé
Maeght, Saint-Paul.

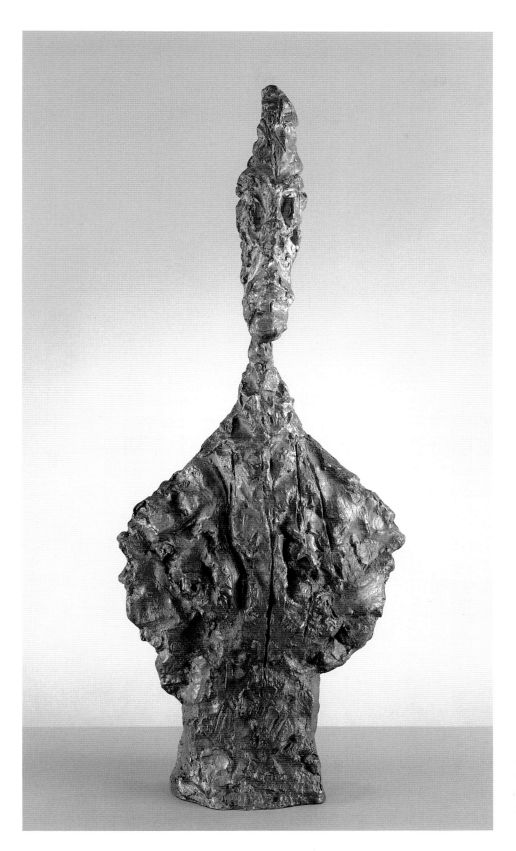

66 *Bust of Diego*, 1957. Bronze, 60.6 × 24.8 × 16 cm. Hirshhorn Museum and Sculpture Garden, Smithsonian Institution. Gift of Joseph H. Hirshhorn, 1966.

67 *Bottle, Bowl, Apple*, 1957.
Pencil on paper, 65 × 50 cm.
Paule and Adrien Maeght
Collection, Paris.

68 *Portrait of Soshana*, 1958.
Pencil on paper, 51.5 × 33.5 cm.
Paule and Adrien Maeght
Collection, Paris.

69 *Standing Man (Portrait of Albert Loeb)*, 1958. Pencil on paper, 48 × 31 cm. Paule and Adrien Maeght Collection, Paris.

70 *Studio Interior*, 1958. Pencil
on paper, 65 × 48 cm. Private
collection.

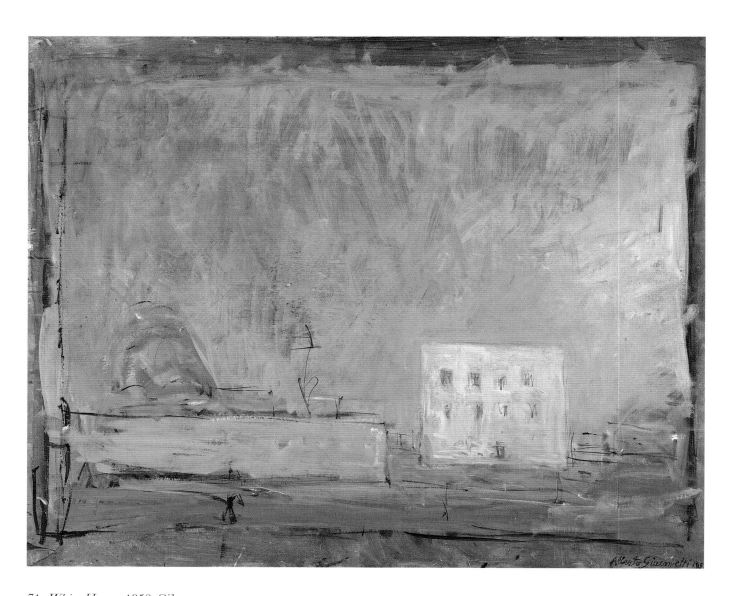

71 *White House*, 1958. Oil on
canvas, 81 × 65 cm. Paule and
Adrien Maeght Collection, Paris.

72 Facing page: *Annette Seated*,
1958. Oil and pencil on canvas,
115.6 × 88.9 cm. The Detroit
Institute of Arts, Founders
Society Purchase, Friends of
Modern Art Fund.

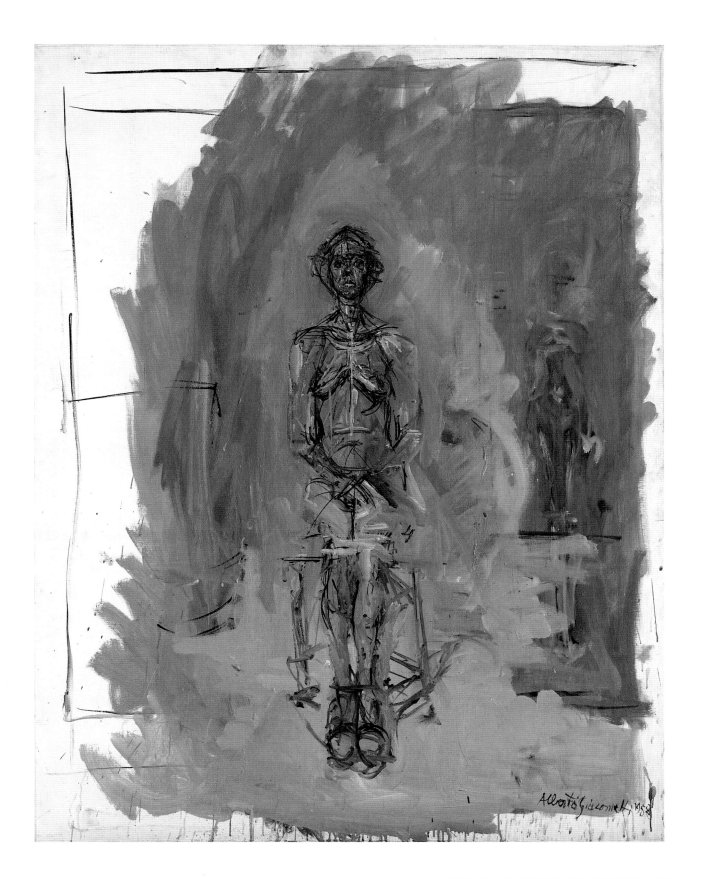

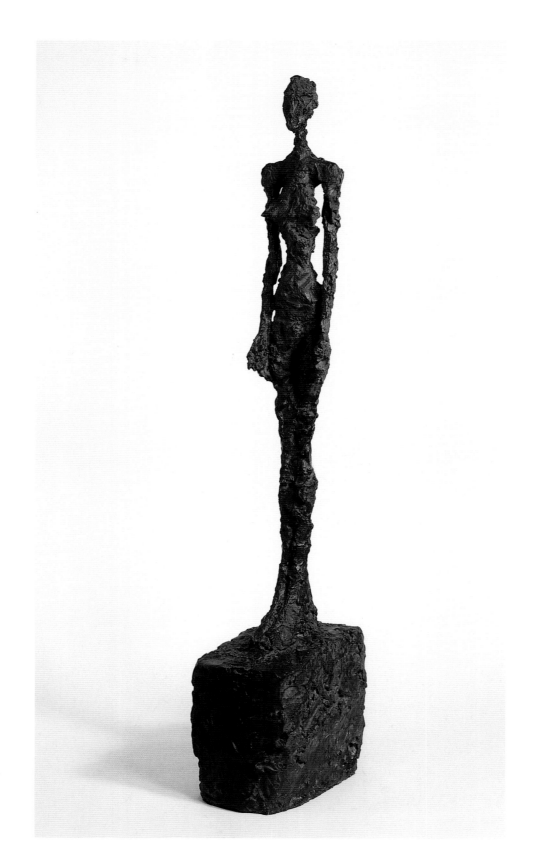

73 *Standing Woman*, 1958–59.
Bronze, 132.1 × 20 × 34.5 cm.
Robert and Lisa Sainsbury
Collection, University of East
Anglia.

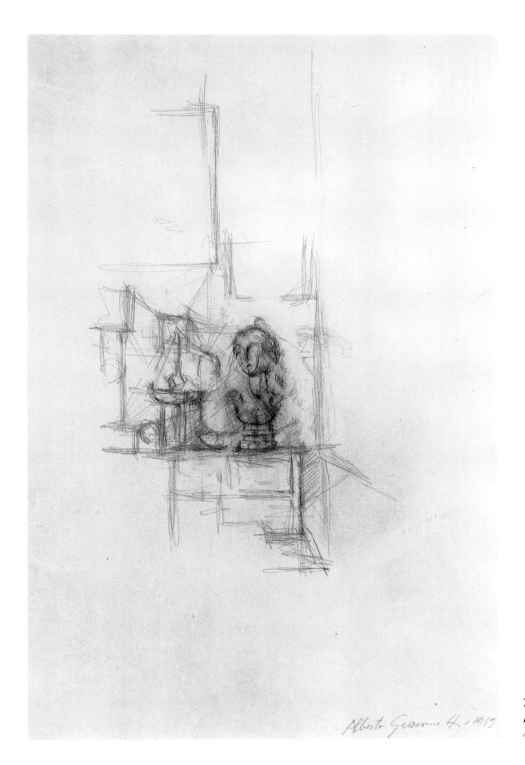

74 *Still life with Bust of a Woman*, 1959. Pencil on paper, 48.8 × 31 cm. Private collection.

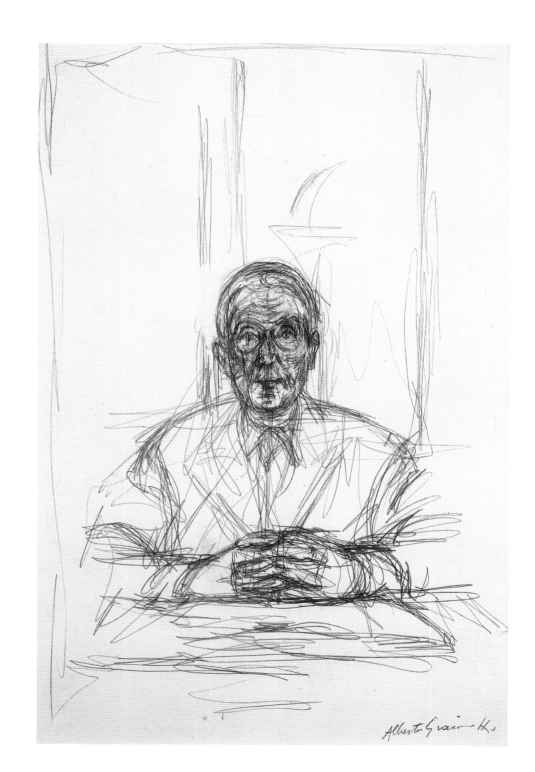

75 *Portrait of Aimé Maeght,*
1959. Pencil on paper, 64 × 49
cm. Paule and Adrien Maeght
Collection, Paris.

76 *Portrait Studies: Pigalle and Egypt IV Dynasty*, 1959. Pencil on paper, 29 × 25 cm. Private collection, Courtesy Art Focus, Zürich.

77 *Caroline*, 1960. Pencil on paper, 21 × 13 cm. Paule and Adrien Maeght Collection, Paris.

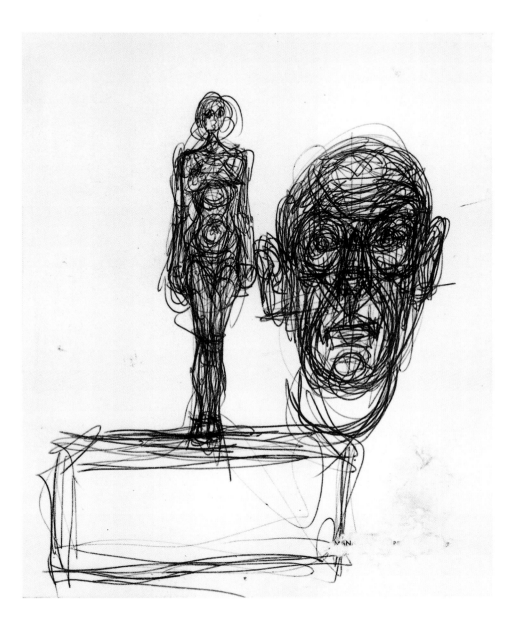

78 *Standing Woman and Head of a Man*, 1960–63. Pencil on paper, 20 × 16 cm. Private collection.

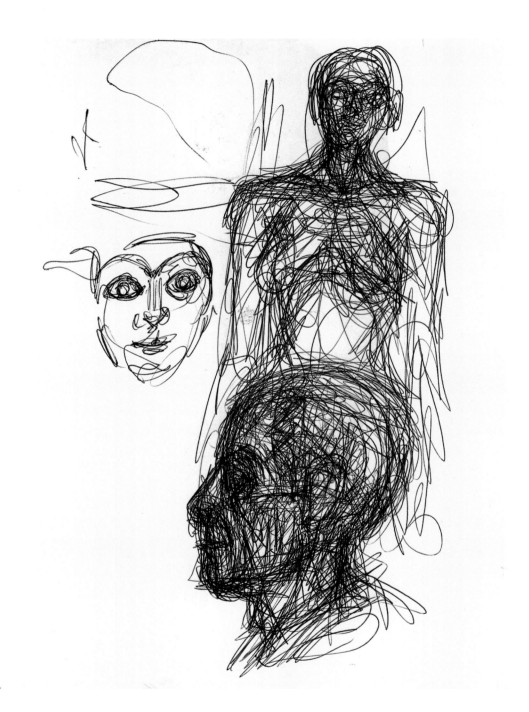

79 *Figures and Two Heads,*
1960–63. Pencil on paper,
30 × 21 cm. Private collection.

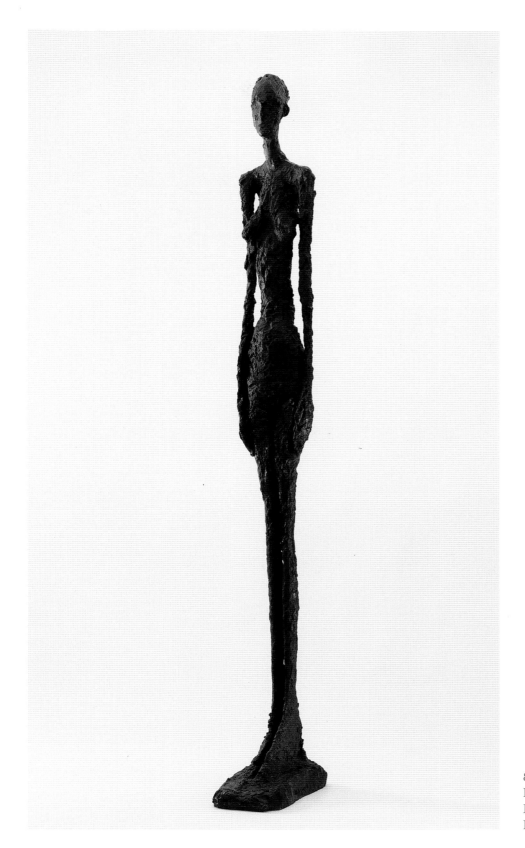

80 *Standing Woman II*, 1960.
Bronze, h. 274.3 cm. The
Detroit Institute of Arts,
Bequest of W. Hawkins Ferry

81 *Landscape, Study for the
'Bateau Ivre', c.* 1961. Pencil on
paper, 31 × 24 cm. Private
collection.

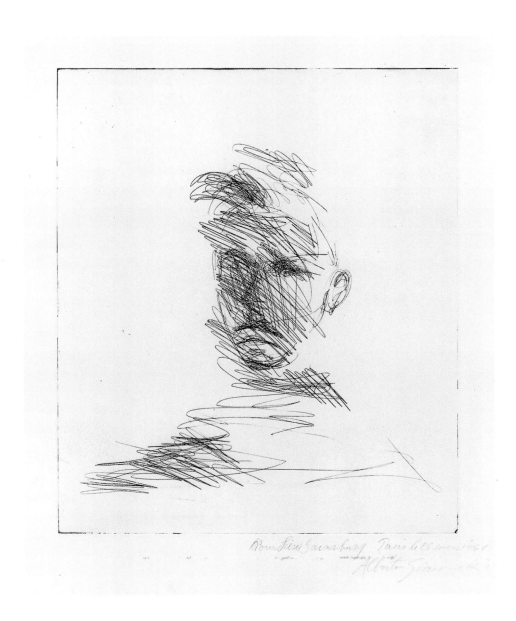

82 *Portrait of Rimbaud*, 1961.
Etching, 28.3 × 24.5 cm. Robert
and Lisa Sainsbury Collection,
University of East Anglia.

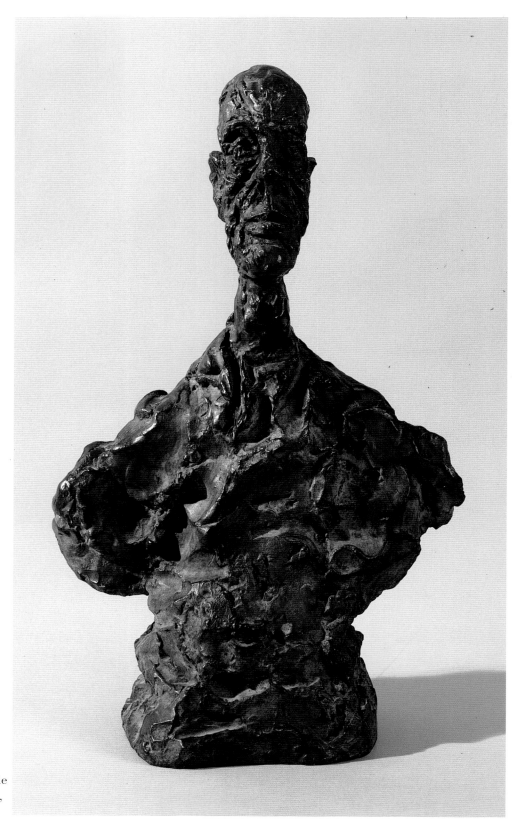

83 *Bust of a Man*, 1961.
Bronze, 46 × 27 × 15 cm.
Private collection.

84 Facing page: *Portrait of
Marguerite Maeght*, 1961. Oil
on canvas, 130 × 96.5 cm. Paule
and Adrien Maeght Collection,
Paris.

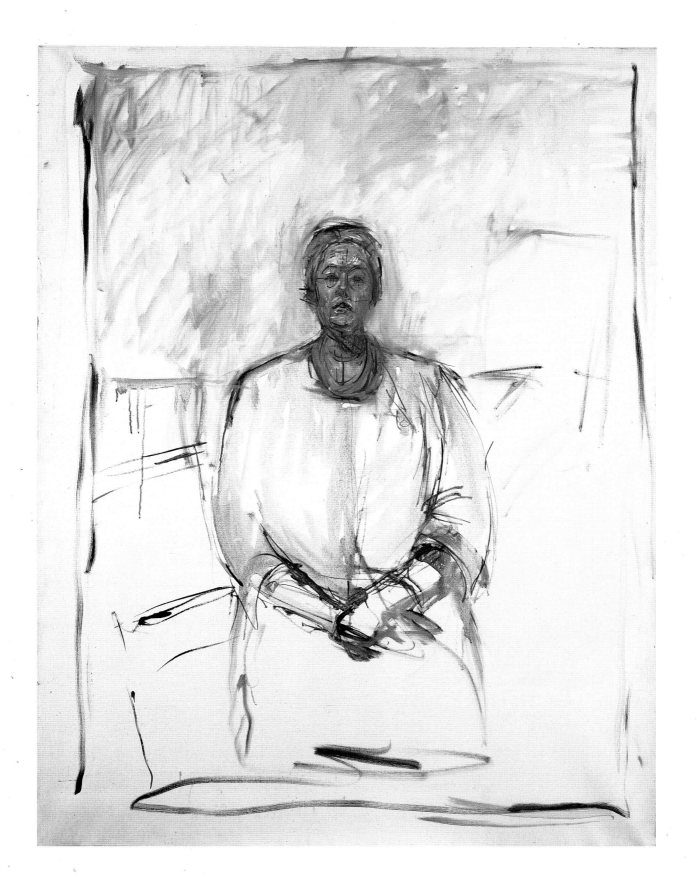

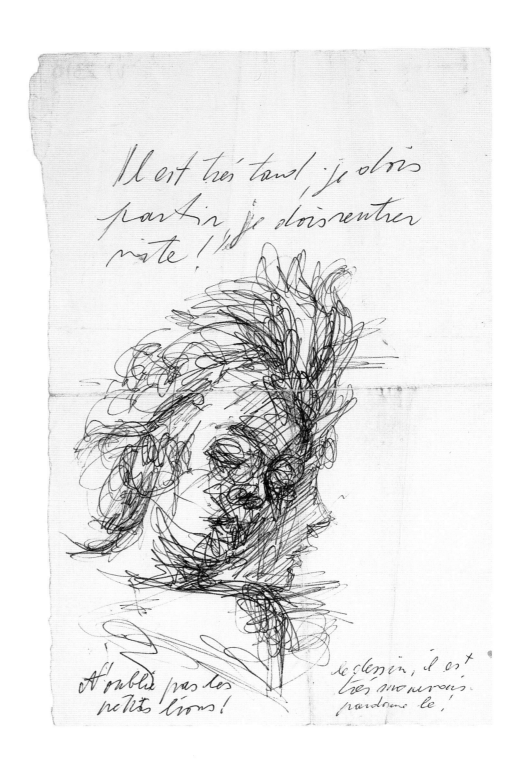

85 *Heads in Profile*, 1961. Pen
on paper, 21 × 13 cm. Paule
and Adrien Maeght Collection,
Paris.

86 *Sleeping Woman*, 1962.
Pencil on paper, 21.5 × 17.5 cm.
Paule and Adrien Maeght
Collection, Paris.

87 *Old Woman*, not dated.
Pencil on paper, 50 × 32 cm.
Paule and Adrien Maeght
Collection, Paris.

88 *Portrait of Reverdy*, 1962.
Pencil on paper, 24 × 19 cm.
Paule and Adrien Maeght
Collection, Paris.

89 *Head of Mother*, 1962.
Pencil on paper, 40 × 31 cm.
Private collection, Courtesy
Pieter Coray.

90 *Mother Reading in Bed*, 1963.
Pencil on paper, 28 × 21 cm.
Private collection.

91 *Mother*, 1963. Pencil on paper, 50 × 32.5 cm. Private collection.

92 *Mother*, 1963. Pencil on paper, 50 × 32.5 cm. Private collection.

93 *Georges Braque on his
Deathbed*, 1963. Pencil on paper,
35.5 × 50 cm. Private collection.

94 *Untitled*, 1963. Pencil on paper. Paule and Adrien Maeght Collection, Paris.

95 *Flowers*, 1964. Crayon on paper, 49.85 × 32.38 cm. Private collection.

96 Facing page: *Annette without Arms (Annette IX)*, 1964. Bronze, 45.7 × 19 × 19 cm. Robert and Lisa Sainsbury Collection, University of East Anglia.

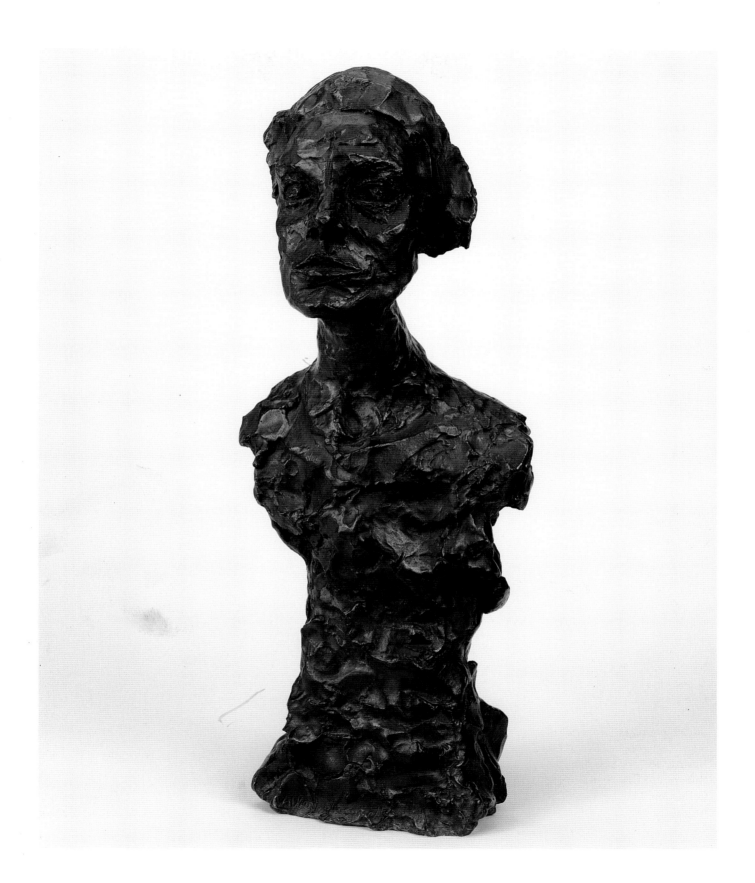

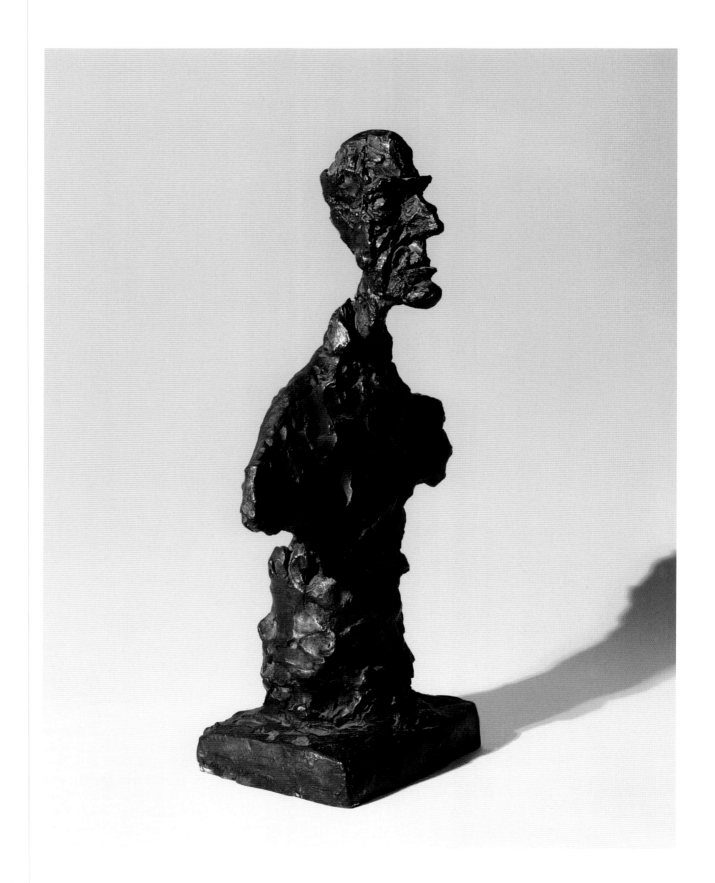

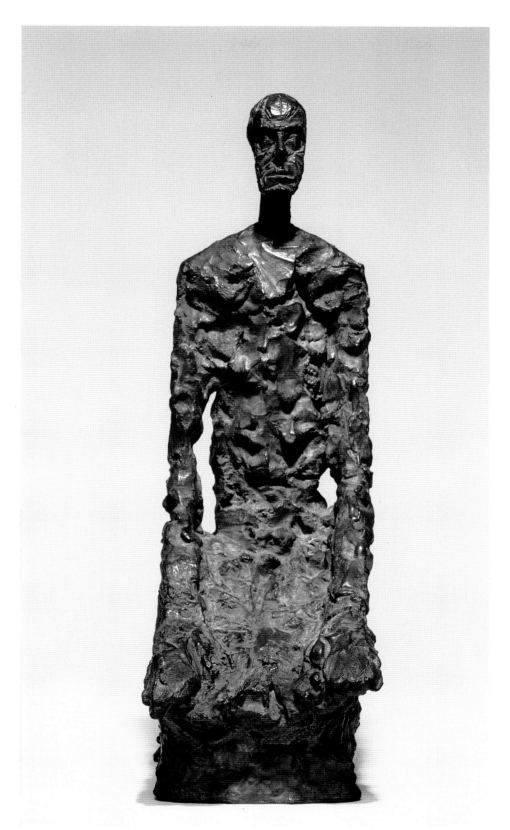

97 Facing page: *Chiavenna II*, 1964. Bronze, 41 × 25 × 13 cm. Private collection.

98 *Diego Seated*, 1964–65. Bronze, h. 59 cm. Louisiana Museum of Modern Art, Humlebaek, Denmark. Donation: The New Carlsberg Foundation, The Augustinus Foundation and the Louisiana Foundation.

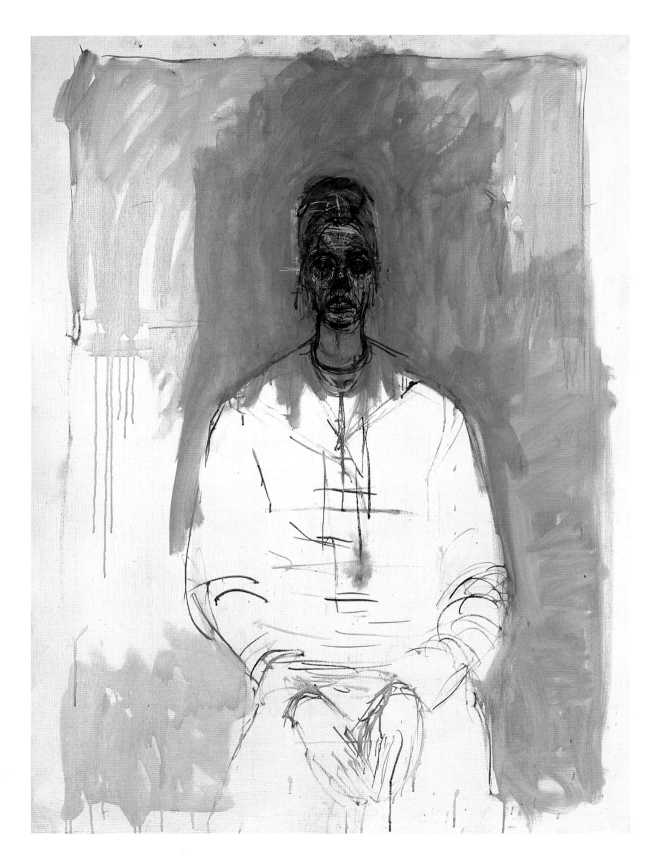

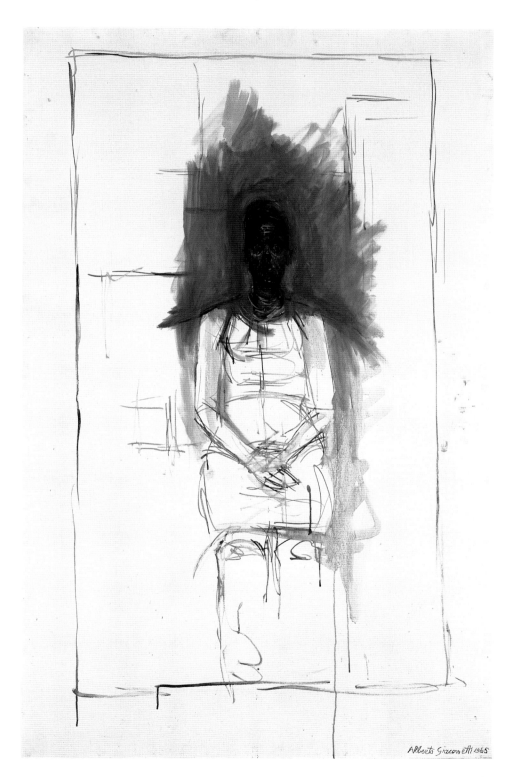

Alberto Giacometti 1965

99 Facing page: *Caroline*,
1964–65. Oil on canvas, 100 × 73
cm. Annette Giacometti Estate.

100 *Caroline*, 1965. Oil on can-
vas, 130.2 × 81.3 cm. Tate.
Purchased with assistance from
Friends of the Tate Gallery, 1965.

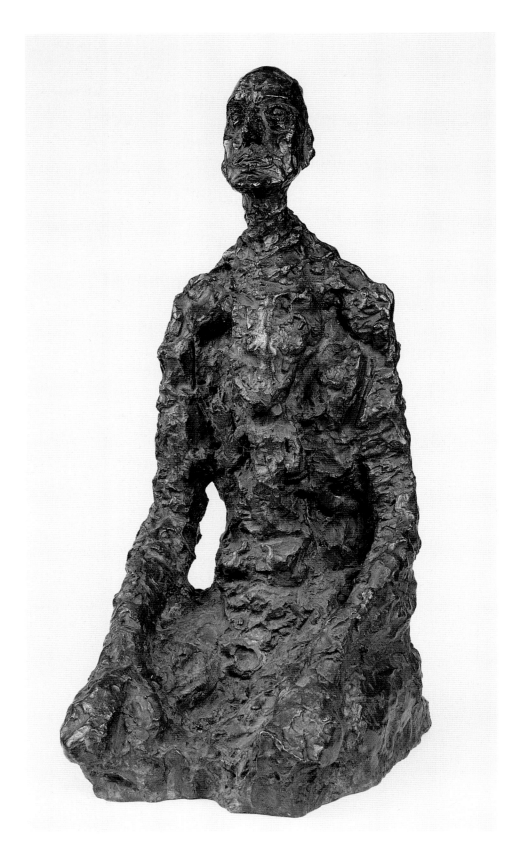

101 *Lotar Seated*, 1965. Bronze,
h. 65.5 cm. Annette Giacometti
Estate.

102 *Robert Sainsbury*, c. 1955.
Oil on canvas, 81 × 54 cm.
Annette Giacometti Estate.

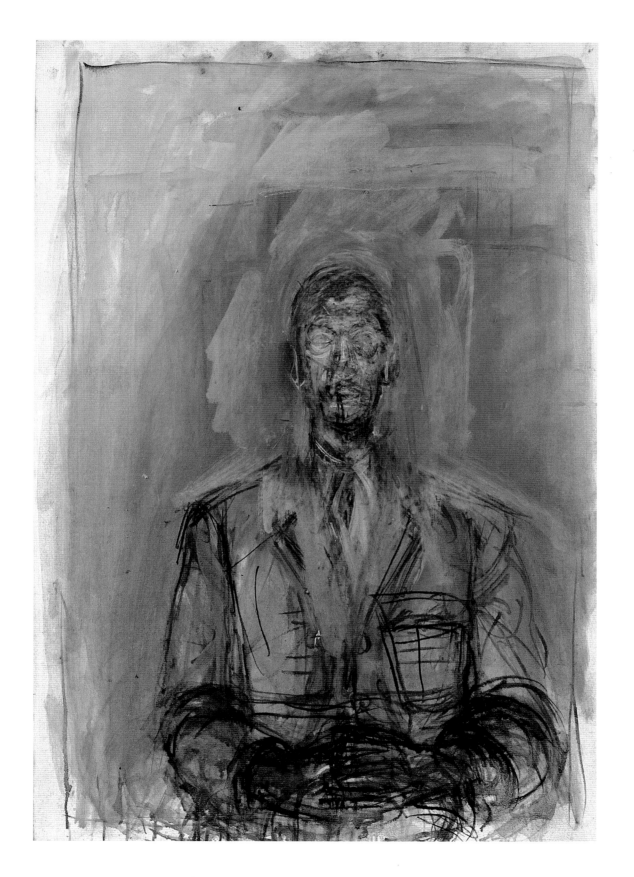

103a Lithograph from *Paris
sans fin*, 1969, 42.5 × 32.4 cm.
Robert and Lisa Sainsbury
Collection, University of East
Anglia.

103b Lithograph from *Paris
sans fin*, 1969, 42.5 × 32.4 cm.
Robert and Lisa Sainsbury
Collection, University of East
Anglia.

103c Lithograph from *Paris sans fin*, 1969, 42.5 × 32.4 cm. Robert and Lisa Sainsbury Collection, University of East Anglia.

103d Lithograph from *Paris sans fin*, 1969, 42.5 × 32.4 cm. Robert and Lisa Sainsbury Collection, University of East Anglia.

STUDIO WALLS

Alberto Giacometti's studio in the rue Hippolyte-Maindron was the centre of his universe. He began renting it in 1927 and, although it struck him at first as too small, he spent the rest of his life there. Over those three decades, the legends around Giacometti and the work being made in the studio turned this modest room behind Montparnasse into a highly charged, visually compelling space.

When Giacometti died, his studio remained intact. Frequently photographed, it came to symbolize Giacometti's way of life, devoted to his art and barely altered by fame. It also stood for his artistic achievement. His most important works had been created there, and poignant traces of Giacometti's daily presence remained in the drawings and notes he made on the studio's pitted, crumbling walls. A few years after the artist's death, the studio was in such disrepair that the walls were removed to preserve the images Giacometti had drawn, painted and scratched on them.

Since then, the walls have rarely left the storage room where they are kept. Giacometti's ability to evoke a whole world in a few lines or marks is marvellously conveyed by these fragmentary murals. We are deeply grateful to the Annette Giacometti Foundation for agreeing to lend them to the exhibition.

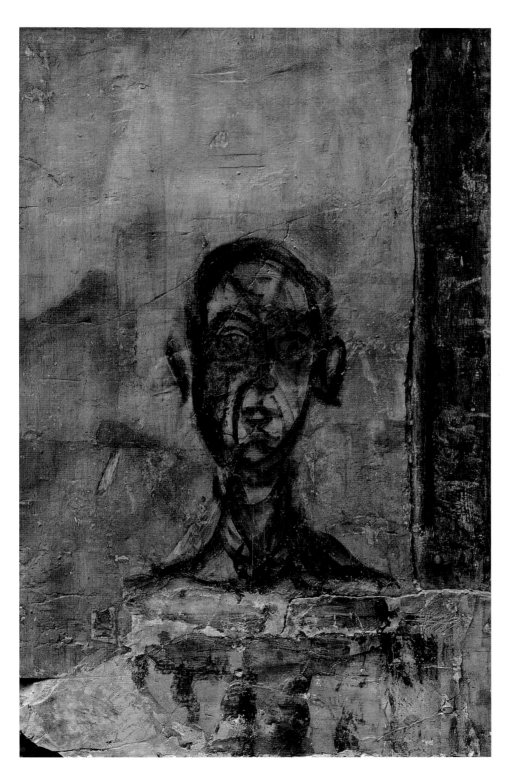

104 *Large Male Head*, undated.
Oil, 98.5 × 62 cm. Annette
Giacometti Estate.

105 *Small Head of Annette*,
project for *Four Women on
Plinths* and *Small Bust* 1964. Oil
and graphite, 47.3 × 63 cm.
Annette Giacometti Estate.

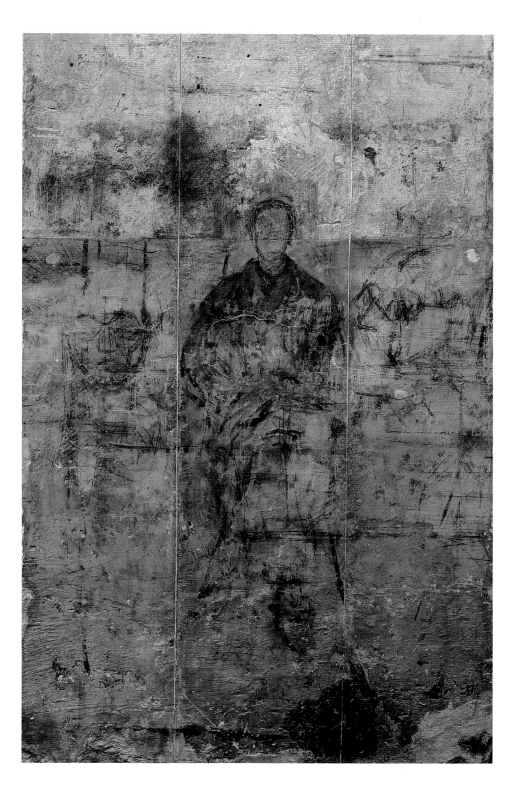

106 *Portrait of Diego Seated, Head of a Woman, Heads*, not dated. Oil and graphite, 151 × 90 cm. Annette Giacometti Estate. Photograph overleaf: Henri Cartier-Bresson, *Alberto Giacometti, rue d'Alésia, Paris*, 1961.

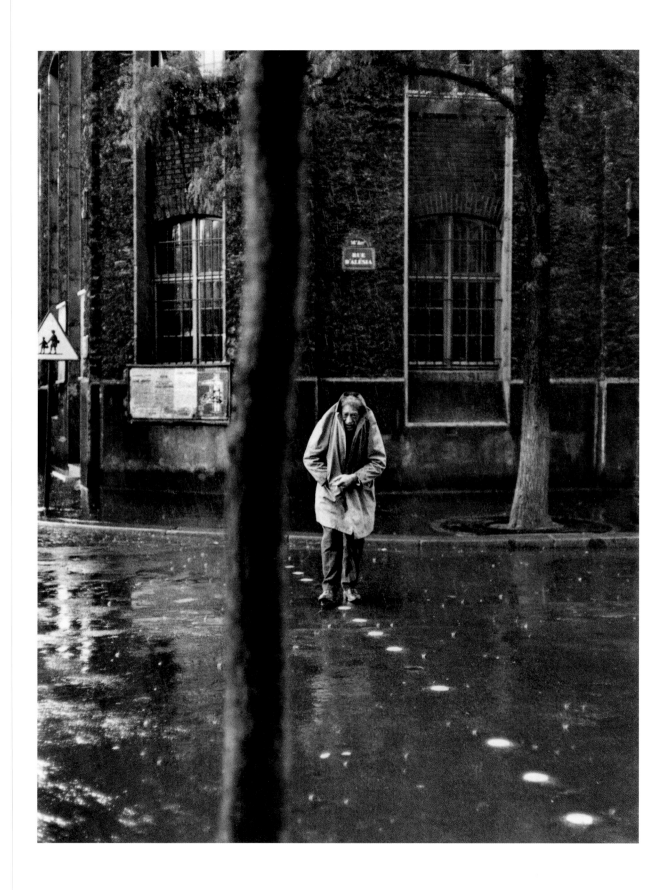

LIST OF WORKS

All dimensions are in centimetres, height by width by depth.

1 *The Skull* 1923
Pencil on paper
22.9 × 21.6 cm
Robert and Lisa Sainsbury
Collection, UEA

2 *Walking Woman* 1932–36
Bronze
149.9 × 27.6 × 37.8 cm
Tate. Presented by the artist and
Mrs Erica Brausen, 1972

3 *Self-portrait* 1935
Pencil on cardboard
30.2 × 24.1 cm
Robert and Lisa Sainsbury
Collection, UEA

4 *Still life,* 1935–36
Bronze, edition 0/8
49 × 69 × 3 cm
Annette Giacometti Estate

5 *Bust of Isabel Rawsthorne* (*Tête
Egyptienne*) 1938–39
Bronze, 29.1 × 21.8 × 24.4
Lent by the Syndics of the
Fitzwilliam Museum, Cambridge

6 *Brooch as a Draped Female
Figure* 1937–38
Gilt bronze
9.2 × 5.2 × 1.5 cm
Robert and Lisa Sainsbury
Collection, UEA

7 *Head of Rita* 1938
Bronze
h. 8.3 cm
Robert and Lisa Sainsbury
Collection

8 *Rita* 1938
Bronze
22 × 13.5 × 16 cm
Kunsthaus Zurich,
Gift of Bruno Giacometti to the
Vereinigung Zürcher
Kunstfreunde

9 *Head of Isabel II* (Isabel
Rawsthorne) 1938–39
Bronze
21.0 × 18.0 cm
Robert and Lisa Sainsbury
Collection, UEA

10 *Isabel* (Rawsthorne) *Reclining*
1940
Pencil on paper
30.5 × 45.7 cm
Robert and Lisa Sainsbury
Collection, UEA

11 *Study of Heads* 1946
Pencil on paper
37 × 26.5 cm
Paule and Adrien Maeght
Collection, Paris

12 *Homage to Balzac* 1946
Pencil on paper
45.4 × 30.5 cm
Robert and Lisa Sainsbury
Collection, UEA

13 *Standing Figure* 1946
Pencil on paper
52.1 × 34.3 cm
Robert and Lisa Sainsbury
Collection, UEA

14 *Simone de Beauvoir,* 1946
Bronze
13.5 × 4 × 4 cm
Annette Giacometti Estate

15 *Untitled* 1946
Oil on canvas
33 × 41 cm
Private Collection

16 *Man Pointing* 1947
Bronze
178 × 95 × 52 cm
Tate. Purchased 1949

17 *Head of a Woman* 1947
Pencil on paper
48.3 × 30.5 cm
Robert and Lisa Sainsbury
Collection, UEA

18 *Seated Woman* 1947
Pencil on paper
48.3 × 30.5 cm
Robert and Lisa Sainsbury
Collection, UEA

19 *Studies for Sculpture* 1947
Oil on canvas
110 × 40 cm
Paul Büchi Foundation,
Switzerland

20 *Small Bust on High Plinth*
(Diego) 1947
Bronze
h. 37.5 cm
Private Collection

21 *Untitled (Giacometti)* 1948
Pencil on paper
29.5 × 24.5 cm
Paule and Adrien Maeght
Collection, Paris

22 *Small Bust on Plinth* 1948–50
Bronze
h. 36.5 cm
Louisiana Museum of Modern
Art, Humlebaek, Denmark

23 *Portrait of the Artist's Brother*
1948
Pencil on paper
49.2 × 30.5 cm
Robert and Lisa Sainsbury
Collection, UEA

24 *Diego Seated* 1948
Oil on canvas
80.6 × 50.2 cm
Robert and Lisa Sainsbury
Collection, UEA

25 *The Tree* 1949
33.3 x 24.8 cm
Robert and Lisa Sainsbury
Collection, UEA

26 *Still Life* 1949
Pencil on paper
36.8 × 52.1 cm
Robert and Lisa Sainsbury
Collection, UEA

27 *The Cage* (First version), 1950
Bronze, edition 1/8
90. 6 × 36.5 × 38 cm
Annette Giacometti Estate

28 *Portrait of the Artist's Mother*
(Annetta) 1949–50
Oil on canvas
68.5 × 62 cm
Private Collection, Courtesy Art
Focus, Zürich

29 *Table in a Room* 1950
Pencil on paper
47.6 × 29.8 cm
Robert and Lisa Sainsbury
Collection, UEA

30 *Standing Woman* 1950
Bronze
30.3 × 7.1 × 9.6 cm
Private Collection, Courtesy
Pieter Coray

31 *The Tree* 1950
Pencil on paper
50.5 × 34.9 cm
Robert and Lisa Sainsbury
Collection, UEA

32 *Cavalier* 1950
Pencil on paper
34.9 × 47.6 cm
Robert and Lisa Sainsbury
Collection, UEA

33 *Self-portrait* 1950
Pencil on paper
56.5 × 47 cm
Private Collection

34 *Diego* 1950
Oil on canvas
80 × 58.4 cm
Robert and Lisa Sainsbury
Collection, UEA

35 *Annette Sitting* 1950
Pencil on paper
49 × 31 cm
Private Collection, Courtesy Art
Focus, Zürich

36 *The Forest* 1950
Bronze
57 × 61 × 49.5 cm
Fondation Marguerite et Aimé
Maeght, Saint-Paul

37 *The Tree* 1950
Oil on canvas
78.7 × 36.1 cm
Robert and Lisa Sainsbury
Collection, UEA

38 *Still Life with Flowers* 1952
Oil on canvas
41 × 35 cm
Paule and Adrien Maeght
Collection, Paris

39 *Woman Working under Light*
1953
pencil on paper
50 × 35 cm
Private Collection, Courtesy
Pieter Coray

40 *Little Sculpture* 1953
81 × 65 cm
Oil on canvas
Private Collection

41 *Diego au Blouson*, 1953.
35.5 × 28 × 10.5 cm.
Bronze
Kunsthaus, Zürich.

42 *Portrait of a Man* 1953
Ink on paper
30 × 24.5 cm
Private Collection

43 *The Tree* 1953
Ink on paper
27.6 × 19.1 cm
Robert and Lisa Sainsbury
Collection, UEA

44 *Seated Woman: Annette* c. 1954
Pencil on paper
48.6 × 31.8 cm
Robert and Lisa Sainsbury
Collection, UEA

45 *Annette*, 1954
Oil on canvas
92 × 73 cm
Annette Giacometti Estate

46 *Standing Nude* 1954
Bronze
75 × 35 × 50 cm
Musée national d'art moderne,
Centre Georges Pompidou, Paris

47 *Bust of Diego* 1954
Bronze
26.7 × 20.5 × 11 cm
Private Collection, Courtesy
Pieter Coray

48 *Bust of Diego* 1954
Bronze
26.7 × 20.5 × 11 cm
Fondation Marguerite et Aimé
Maeght, Saint-Paul

49 *Thin Bust on Plinth (Amenophis)*
1954
Bronze
39 × 32 × 13 cm
Private Collection

50 *Matisse* 1954
Pencil on paper
45 × 32 cm
Private Collection

51 *Telegram to Diego* 1955–60
Pencil on paper
16.5 × 21 cm
Private Collection

52 *Standing Nude* 1955
Bronze
27 × 10 × 10 cm
Private Collection, Courtesy
Pieter Coray

53 *Standing Nude* 1955
Pencil on paper
63.8 × 48.3 cm
Robert and Lisa Sainsbury
Collection, UEA

54 *David – Profile* 1955
Pencil on paper
47.9 × 31.4 cm
Robert and Lisa Sainsbury
Collection

55 *David – Full Length* 1955
Pencil on paper
55.2 × 37.5 cm
Robert and Lisa Sainsbury
Collection

56 *David – Head and Shoulders*
1955
Pencil on paper
55.2 × 37.5 cm
Robert and Lisa Sainsbury
Collection

57 *Elizabeth – Head and Shoulders 1*
1955
Pencil on paper
47.9 × 31.8 cm
Robert and Lisa Sainsbury
Collection

58 *Elizabeth – Head and Shoulders 2*
1955
Pencil on paper
47.9 × 31.8 cm
Robert and Lisa Sainsbury
Collection

59 *Elizabeth – Head and Shoulders 3*
1955
Pencil on paper
47.9 × 31.8 cm
Robert and Lisa Sainsbury
Collection

60 *Elizabeth - Head and Shoulders 4*
1955
Pencil on paper
55.2 × 37.5 cm
Robert and Lisa Sainsbury
Collection

61 *Landscape (Stampa)* 1955
Pencil on paper
48.5 × 34.5 cm
Private Collection, Courtesy Art
Focus, Zürich

62 *Self-portrait* 1955
Pencil on paper
47.5 × 30.5 cm
Private Collection

63 *Portrait of Yanaihara* 1956
Oil on canvas
80 × 64.5 cm
Private Collection, Courtesy Art
Focus, Zürich

64 *Venice Woman I* 1956
Bronze
106 × 13.5 × 29.5 cm
Fondation Marguerite et Aimé
Maeght, Saint-Paul

65 *Venice Woman VII* 1956
Bronze
117 × 16.5 × 36.5 cm
Fondation Marguerite et Aimé
Maeght, Saint-Paul

66 *Bust of Diego* 1957
Bronze
60.6 × 24.8 × 16 cm
Hirshhorn Museum and
Sculpture Garden, Smithsonian
Institution. Gift of Joseph H.
Hirshhorn, 1966.

67 *Bottle, Bowl, Apple*, 1957. Pencil
on paper, 65 × 50 cm. Paule and
Adrien Maeght Collection,
Paris.

68 *Portrait of Soshana* 1958
Pencil on paper
51.5 × 33.5 cm
Paule and Adrien Maeght
Collection, Paris

69 *Standing Man* (*Portrait of
Albert Loeb*) 1958
Pencil on paper
48 × 31 cm
Paule and Adrien Maeght
Collection, Paris

70 *Studio Interior* 1958
Pencil on paper
65 × 48 cm
Private Collection

71 *White House* 1958
Oil on canvas
81 × 65 cm
Paule and Adrien Maeght
Collection, Paris

72 *Annette Seated* 1958
Oil and pencil on canvas
115.6 × 88.9 cm
The Detroit Institute of Arts,
Founders Society Purchase,
Friends of Modern Art Fund

73 *Standing Woman* 1958–59
Bronze
132.1 × 20.0 × 34.5 cm
Robert and Lisa Sainsbury
Collection, UEA

74 *Still Life with Bust of a Woman*
1959
Pencil on paper
48.8 × 31 cm
Private Collection

75 *Portrait of Aimé Maeght* 1959
Pencil on paper
64 × 49 cm
Paule and Adrien Maeght
Collection, Paris

76 *Portrait Studies: Pigalle and
Egypt IV Dynasty* 1959
Pencil on paper
29 × 25 cm
Private Collection, Courtesy Art
Focus, Zürich

77 *Caroline* 1960
Pencil on paper
21 × 13 cm
Paule and Adrien Maeght
Collection, Paris

78 *Standing Woman and Head of a Man* 1960–63
Pencil on paper
20 × 16 cm
Private Collection

79 *Figures and Two Heads* 1960–63
Pencil on paper
30 × 21 cm
Private Collection

80 *Standing Woman II* 1960
274.3 cm
Bronze
The Detroit Institute of Arts,
Bequest of W. Hawkins Ferry

81 *Landscape: Study for the* Bateau
Ivre *c.* 1961
Pencil on paper
31 × 24 cm
Private Collection

82 *Portrait of Rimbaud* 1961
Etching
28.3 × 24.5 cm
Robert and Lisa Sainsbury
Collection, UEA

83 *Bust of a Man* 1961
Bronze
46 × 27 × 15 cm
Private Collection

84 *Portrait of Marguerite Maeght*
1961
Oil on canvas
130 × 96.5 cm
Paule and Adrien Maeght
Collection, Paris

85 *Heads in Profile* 1961
Pen on paper
21 × 13 cm
Paule and Adrien Maeght
Collection, Paris

86 *Sleeping Woman* 1962
Pencil on paper
21.5 × 17.5 cm
Paule and Adrien Maeght
Collection, Paris

87 *Old Woman,* not dated
Pencil on paper
50 x 32 cm
Paule and Adrien Maeght
Collection, Paris

88 *Portrait of Reverdy* 1962
Pencil on paper
24 × 19 cm
Paule and Adrien Maeght
Collection, Paris

89 *Head of Mother* 1962
Pencil on paper
40 × 31 cm
Private Collection, Courtesy
Pieter Coray

90 *Mother Reading in Bed* 1963
Pencil on paper
28 × 21 cm
Private Collection

91 *Mother* 1963
Pencil on paper
50 × 32.5 cm
Private Collection

92 *Mother* 1963
Pencil on paper
50 × 32.5 cm
Private Collection

93 *George Braque on his Deathbed*
1963
Pencil on paper
33.5 × 50 cm
Private Collection

94 *Untitled* 1963
Pencil on paper
Paule and Adrien Maeght
Collection, Paris

95 *Flowers* 1964
Crayon on paper
49.85 × 32.38
Private Collection

96 *Annette without Arms* (*Annette IX*) 1964
Bronze
45.7 × 19.0 × 19.0 cm
Robert and Lisa Sainsbury
Collection, UEA

97 *Chiavenna II* 1964
Bronze
41 × 25 × 13
Private Collection

98 *Diego Seated* 1964–65
Bronze
h. 59 cm
Louisiana Museum of Modern
Art, Humlebaek, Denmark
Donation: The New Carlsberg
Foundation, The Augustinus
Foundation and the Louisiana
Foundation

99 *Caroline*, 1964–65
Oil on canvas
100 × 73 cm
Annette Giacometti Estate

100 *Caroline* 1965
Oil on canvas
130.2 × 81.3 cm
Tate. Purchased with assistance
from the Friends of the Tate
Gallery, 1965

101 *Lotar Seated*, 1965
Bronze
65.5 × 27.5 × 35 cm
Annette Giacometti Estate

102 *Robert Sainsbury, c.* 1955
Oil on canvas
81 × 54 cm
Annette Giacometti Estate

103 *Paris sans fin* 1969
Portfolio of 150 lithographs and
text
42.5 × 32.4 cm
Robert and Lisa Sainsbury
Collection, UEA

STUDIO WALLS

104 *Large Male Head*
Oil
98.5 × 62 cm
Annette Giacometti Estate

105 *Small Head of Annette*, project
for *Four Women on Plinths* and
Small Bust, 1964
Oil and graphite
47.3 × 63 cm
Annette Giacometti Estate

106 *Portrait of Diego Seated, Head
of a Woman, Heads*
Oil and graphite
151 × 90 cm
Annette Giacometti Estate

PHOTOGRAPHS

The following black and white photographs have been
kindly lent by the Schweizerische Stiftung für die
Photographie, Zürich (Swiss Foundation for
Photography, Zürich).

ERNST SCHEIDEGGER

107 *In the Studio, Paris c.* 1953

108 *In the Studio, Paris c.* 1953

109 *Plaster cast of the* Spoon Woman
(1926) *in the Studio, c.* 1953

CHRONOLOGY

1901 Alberto Giacometti born 10 October in Borgonovo, a village in the Italian-speaking Bregaglia Valley, Switzerland, to Giovanni Giacometti (1868–1933), a post-Impressionist painter, and Annetta Giacometti, *née* Stampa (1871–1964). Eldest of four children: Diego (1902–85), later Alberto's right-hand man and most constant model in Paris; a sister, Ottilia (1904–37); and Bruno (b. 1907), who became a respected architect.

1904–14 The family moved to the larger, nearby village of Stampa. In the barn adjoining their new house, Giovanni set up his studio, where Alberto made his earliest drawings, inspired by fairy tales and illustrated art books. Holidays were spent further up the valley in a chalet at Maloja. Alberto returned to Stampa and Maloja almost every summer for the rest of his life. After completing his first two oil paintings (a still-life and a landscape), he made busts of his two brothers in Plasticine.

1915–19 Attended a boarding school at Schiers, where he had the use of a small studio. Read widely in German, notably the Romantic poets. Drew portraits of his schoolfriends and painted Fauvist landscapes. In 1919 left school and moved to Geneva where he studied drawing and painting at the Ecole des Beaux-Arts and sculpture at the Ecole des Arts-et-Métiers. His paintings during this period reflect the pointillist technique adopted by his father and his Beaux-Arts teacher. Contracted mumps, which left him sterile.

1920-2 Accompanied his father to Venice, where he was especially impressed by Tintoretto, and later, in Padua, by Giotto's Arena Chapel frescoes. Subsequent stays in

Florence and Rome, where he made drawings after the Old Masters. Visited Naples, Paestum and Pompeii. A chance acquaintance, Pieter van Meurs, died while he and Giacometti were travelling together. The experience left the young artist acutely conscious of death's omnipresence, and he would never again go to sleep without a light being left on.

1922-24 Arrived in Paris in January 1922. Studied sculpture under Antoine Bourdelle (a former pupil of Rodin) at the Académie de la Grande Chaumière in Montparnasse. Frequent visits to the Louvre to study the art of the past. Lived mostly in cheap hotels.

1925–27 Rented second-floor studio overlooking Montparnasse Cemetery at 37 rue Froidevaux, which Diego shared after his arrival in Paris in February 1925. Exhibited work at Salon des Tuileries. Visited Henri Laurens and Jacques Lipchitz and saw their recent work. Made first Cubist sculptures. Influenced by African, Egyptian and Cycladic art. Executed *Spoon Woman* and several flattened heads. In spring 1927 moved to small, dilapidated studio at 46 rue Hippolyte-Maindron, behind Montparnasse, where he lived and worked until his death.

1928–31 Showed six sculptures including *The Couple* at the Salon de l'Escalier in 1928 and two sculptures in 1929 at Galerie Jeanne Bucher. *Gazing Head*, a plaque sculpture, acquired by leading collectors Charles and Marie-Laure de Noailles. Through André Masson, met Jean Arp, Antonin Artaud, Max Ernst, Joan Miró and other writers and artists connected with the Surrealist movement. First article on Giacometti, by poet and ethnologist Michel Leiris, published in *Documents*. First sculptures with cage-like structures and ambiguously erotic moving parts. Exhibited with Arp and Miró at Galerie Pierre. Was invited by Breton, who saw his *Suspended Ball* (1930) there, to join the Surrealist group. With Diego began designing lamps, vases and other decorative objects for interior decorator Jean-Michel Frank as well as gold-bronze jewellery for couturière Elsa Schiaperelli.

1932–34	Completed two major works, *Woman with her Throat Cut* and *The Palace at 4am*, adopting Surrealist techniques to explore semi-conscious fantasies. First solo exhibition at Galerie Pierre Colle (May 1932). Review of his work published in *Cahiers d'Art* with photographs of seven sculptures by Man Ray. Showed several works in Surrealist group show, including *Surrealist Table*. Father died in 1933. In summer 1934 took Max Ernst to Maloja where both artists carved and painted boulders. First solo exhibition in the United States, *Abstract Sculpture by Alberto Giacometti*, at Julien Levy Gallery, New York. Participated in Surrealist group exhibitions in Europe and America. Began working from life rather than from his imagination in late 1934, thus implicitly rejecting Surrealism. Excluded from Surrealist group shortly thereafter.
1935–40	Series of busts made directly from live models, notably Diego and Isabel Delmer (later Rawsthorne). Began friendship with André Derain, Balthus and Samuel Beckett. Sister Ottilia died after giving birth to a son, Silvio. Destroyed many sculptures and began paring down figures in plaster until they almost disappeared. In 1937, on annual summer holiday in Stampa, painted portrait of his mother and two still-lifes influenced by Cézanne that prefigure his mature postwar style. An injury to his foot left him with a slight but permanent limp. In 1939 met Jean-Paul Sartre who wrote two influential essays on his work. Saw Picasso more frequently. The *Palace at 4am* acquired by Museum of Modern Art, New York. Buried tiny sculptures in corner of studio before attempting, unsuccessfully, to flee Paris in June 1940.
1941–44	Left Paris in December 1941 with visa to visit his mother in Switzerland. Lived in cheap hotel room in Geneva throughout the war and modelled increasingly tiny heads and figures. Completed one large sculpture, *Woman on a Chariot*. In 1943 met Annette Arm (1923–93).

1945-49	Returned to Paris in September 1945 to find that Diego had managed to keep his studio exactly as he had left it. Began affair with Isabel Delmer. In 1946 Annette arrived in Paris, moved into the studio and began posing regularly for the artist. Later an adjacent room would be rented as their bedroom. Took up painting regularly again for the first time since the mid-1920s. Drew ceaselessly, testing his vision and exploring spatial relationships. The tiny plaster models began to grow into the sculptor's distinctive, skeletal figures. Also made disembodied fragments, notably *The Nose* and *Hand*, after having witnessed a neighbour's death. Retrospective at Pierre Matisse Gallery in New York which included Surrealist works, recent standing figures, paintings and drawings. Catalogue contained long text by artist on his stylistic development and Sartre's essay, *The Search for the Absolute*. Tate Gallery bought two paintings and the sculpture *Man Pointing*. Married Annette in July 1949.
1950–55	Made series of figure compositions on large plinths and elongated stands as well as groups of figures, such as *The Forest*. Second exhibition at Pierre Matisse Gallery and first solo exhibition at Galerie Maeght in Paris confirmed growing reputation. The Museum of Modern Art in New York bought *Woman with her Throat Cut*, *The Chariot* and *Man Pointing*. Made more realistic, frontal portraits of Diego and other personalities in his orbit, such as the American collector G. David Thompson, the dealer Aimé Maeght, the painter Henri Matisse and the ex-convict poet and writer, Jean Genet. 'I shall never succeed in putting into a portrait all the power a head contains,' the artist said at the time. 'The very fact of living already requires so much willpower and energy…' First exhibition in UK, organized by Arts Council. Other exhibitions in Germany and at the Guggenheim Museum, New York.
1956–60	Exhibited group of ten new female figures, made from memory and all just over a metre high, at the Venice Biennale. Retrospective at Kunsthalle in Bern. First portraits of Isaku Yanaihara, a Japanese professor of

philosophy. Dissatisfied, the artist began repainting his portraits obsessively, convinced that he would always fail to convey the reality of the person before him. 'My whole work has been called into question in a way that hasn't happened since 1935,' he noted at the time. Third exhibition at Galerie Maeght with catalogue essay by Genet. Despite growing fame and wealth, changed little in his spartan daily routine, rising around midday and working through the afternoon and the night. Made seven monumental figures in a project for Chase Manhattan Bank Plaza in New York, but they were never installed. Met Caroline, a young prostitute who became his mistress and the subject of numerous portraits.

1961–66 Created stage set consisting of a single plaster tree for production of Beckett's *Waiting for Godot*. Last portrait of Yanaihara. Further busts of Annette and Diego characterized by intensity of their gaze. Major retrospective at Kunsthaus Zurich. Underwent surgery for stomach cancer in 1963. Mother died in 1964. Three busts of the Romanian photographer Elie Lotar. Fondation Maeght opened in South of France with large collection of Giacometti sculptures. Major retrospectives at Tate Gallery, London, and Museum of Modern Art, New York. Produced 150 lithographs with text, entitled *Paris sans fin* and published posthumously. Health deteriorated. Left Paris in December 1965 for Cantonal Hospital in Chur, Switzerland, dying there of heart failure on 11 January 1966. Buried beside parents in graveyard outside Stampa.

SELECTED BIBLIOGRAPHY

BONNEFOY 1991 — Bonnefoy, Yves. *Alberto Giacometti: Biographie d'une oeuvre*. Paris, 1991. English trans., *Alberto Giacometti: A Biography of his Work*. Paris, 1991.

CARLUCCIO 1967 — Carluccio, Luigi. *Alberto Giacometti: Le copie del passato*. Turin, 1967. English trans., *Alberto Giacometti: A Sketchbook of Interpretive Drawings*. New York, 1968.

CHARBONNIER 1959 — Charbonnier, Georges. *Le Monologue du Peintre*. Paris, 1959.

CLAIR 1992 — Clair, Jean. *Le Nez de Giacometti: Faces de carême, Figures de carnaval*. Paris, 1992.

DI CRESCENZO 2000 — Di Crescenzo, Casimiro. 'Dialoghi con l'arte: le copie del passato.' In *Alberto Giacometti: Dialoghi con l'arte*. Mendrisio, Museo d'arte, 2000.

DUFRENE 1991 — Dufrêne, Thierry. *Alberto Giacometti: Portrait de Jean Genet, le scribe captif*. Paris, 1991.

DUPIN 1962 — Dupin, Jacques. *Alberto Giacometti*. Paris, 1962. English trans., Alberto Giacometti. Paris, 1962.

FLETCHER 1998 — Fletcher, Valerie J. 'Alberto Giacometti: His Art and Milieu.' In *Alberto Giacometti 1901–1966*. Washington, Hirshhorn Museum and Sculpture Garden, Smithsonian Institution, 1998.

GENET 1958 — Genet, Jean. *L'Atelier d'Alberto Giacometti*. Décines, 1958. English trans., 'Alberto Giacometti's Studio,' in *Alberto Giacometti – The Artist's Studio*. Liverpool, Tate Gallery, 1991.

HOHL 1972 — Hohl, Reinhold. *Alberto Giacometti*. Stuttgart, 1971. English trans., *Alberto Giacometti: Sculpture, Painting, Drawing*. London, 1972.

HOHL 1998 — Hohl, Reinhold. *Giacometti: A Biography in Pictures*. Ostfildern-Ruit, 1998.

KLEMM 2001 — Klemm, Christian. 'Alberto Giacometti, 1901–1966.' In *Alberto Giacometti*, Museum of Modern Art, New York, 2001.

LEIRIS 1929 — Leiris, Michel. 'Alberto Giacometti.' *Documents*, no. 4. English trans., in *Sulfur* 15 (1986).

LEIRIS/DUPIN 1990 — *Ecrits/Alberto Giacometti*. Edited by Michel Leiris and Jacques Dupin. Paris, 1990.

LORD 1965 — Lord, James. *A Giacometti Portrait*. New York, 1965.

LORD 1985 Lord, James. *Alberto Giacometti: A Biography*. New York, 1985.

LORD 1996 Lord, James. '46, rue Hippolyte and After,' in *Some Remarkable Men: Further Memories*. New York, 1996.

MEGGED 1985 Megged, Matti. *Dialogue in the Void: Beckett and Giacometti*. New York, 1985.

NADEAU 1945 Maurice Nadeau. *Histoire du sur-réalisme*. Paris, 1945.
English trans., *The History of Surrealism*. New York, 1965.

PARINAUD 1962 Parinaud, André. 'Entretien avec Giacometti: "Pourquoi je suis sculpteur."' *Arts-Lettres-Spectacles*, no. 873, 1962.

SARTRE 1948 Sartre, Jean-Paul. 'La recherche de l'absolu.' *Les Temps Modernes* 3, no. 28, 1948. English trans., 'The Search for the Absolute,' in *Alberto Giacometti*, Pierre Matisse Gallery, New York, 1948.

SCHEIDEGGER 1990 Scheidegger, Ernst. *Spuren einer Freundschaft, Alberto Giacometti*. Zürich, 1990.

SCHNEIDER 1960 Schneider, Pierre. 'Au Louvre avec Alberto Giacometti.' *Preuves*, no. 139, 1960.

SYLVESTER 1994 Sylvester, David. *Looking at Giacometti*. London, 1994.

SELECTED EXHIBITION CATALOGUES

PARIS 1933 Galerie Pierre Colle, Paris.
Exposition surréaliste,
7–18 June 1933.

NEW YORK 1934 Julien Levy Gallery, New York.
Abstract Sculpture by Alberto Giacometti,
1 December 1934 –
1 January 1935.

NEW YORK 1945 Art of This Century, New York.
Alberto Giacometti,
10 February – 10 March 1945.

NEW YORK 1948 Pierre Matisse Gallery, New York.
Alberto Giacometti,
19 January – 14 February 1948.

BASEL 1950 Kunsthalle, Basel.
André Masson, Alberto Giacometti,
6 May – 11 June, 1950.

NEW YORK 1950 Pierre Matisse Gallery, New York.
Alberto Giacometti,
November 1950 – January 1951.

PARIS 1951 Galerie Maeght, Paris.
Alberto Giacometti,
8 – 30 June 1951.

PARIS 1954 Galerie Maeght, Paris.
Alberto Giacometti,
May 1954.

LONDON 1955 Arts Council Gallery, London.
Alberto Giacometti,
4 June – 9 July 1955

NEW YORK 1955 Solomon R. Guggenheim, New York.
Alberto Giacometti,
7 June – 17 July 1955.

BERN 1956 Kunsthalle, Bern.
Alberto Giacometti,
16 June – 22 July 1956.

VENICE 1956 Padiglione Francese, Venice.
XXVIII Esposizione Biennale Internazionale d'Arte, Venezia,
16 June – 21 October 1956.

NEW YORK 1958 Pierre Matisse Gallery, New York.
Giacometti: Sculpture, Paintings, Drawings from 1956 to 1958,
6 – 31 May 1958.

PARIS 1961 Galerie Maeght, Paris.
Alberto Giacometti,
May 1961.

TURIN 1961 Galleria Galatea, Turin.
Alberto Giacometti,
29 September –
25 October 1961.

NEW YORK 1961 Pierre Matisse Gallery, New York.
Alberto Giacometti,
12 – 30 December 1961.

VENICE 1962 Padiglione Centrale, Venice.
XXXI Esposizione Biennale Internazionale d'Arte, Venezia,
16 June – 7 October 1962.

ZÜRICH 1962	Kunsthaus, Zürich. *Alberto Giacometti*, 2 December 1962 – 20 January 1963.
LONDON 1965	Tate Gallery, London. *Alberto Giacometti: Sculpture, Paintings, Drawings 1913–1965*, 17 July – 30 August 1965.
NEW YORK 1965	The Museum of Modern Art, New York. *Alberto Giacometti: Sculpture, Paintings and Drawings*, 9 June – 10 October 1965.
BASEL 1966	Kunsthalle, Basel. *Giacometti*, 25 June – 28 August 1966.
PARIS 1969	Musée de l'Orangerie des Tuileries, Paris. *Alberto Giacometti*, 24 October 1969 – 12 January 1970.
NEW YORK 1974	Solomon R. Guggenheim Museum, New York. *Alberto Giacometti: A Retrospective Exhibition*, 5 April – 23 June 1974.
SAINT-PAUL-DE-VENCE 1978	Fondation Maeght, Saint-Paul-de-Vence. *Alberto Giacometti*, 8 July – 30 September, 1978.
PARIS 1979	Galerie Maeght, Paris. *Alberto Giacometti: Les Murs de l'atelier et de la chambre*, 29 March – 10 May 1979.
NORWICH 1984	Sainsbury Centre for Visual Arts, University of East Anglia. *Alberto Giacometti, The Last Two Decades*, 30 March – 17 June 1984
PARIS 1984	Galerie Maeght, Paris. *Alberto Giacometti: Plâtres peints*, 21 June – 27 July 1984.
GENEVA 1986	Musée Rath, Geneva. *Alberto Giacometti: Retour à la figuration, 1933–1947*, 3 July – 28 September 1986.
MARTIGNY 1986	Fondation Pierre Gianadda, Martigny. *Alberto Giacometti*, 15 May – 2 November 1986.
BERLIN 1987	Nationalgalerie Berlin, Staatliche Museen Preussischer Kulturbesitz, Berlin. *Alberto Giacometti*, 9 October 1987 – 3 January 1988.
WASHINGTON 1988	Hirshhorn Museum and Sculpture Garden, Smithsonian Institute, Washington, D.C. *Alberto Giacometti: 1901–1966*, 15 September – 13 November 1988.
PARIS 1991	Musée d'Art Moderne de la Ville de Paris. *Alberto Giacometti: Sculptures, peintures, dessins*, 30 November 1991 – 15 March 1992.
MILAN 1995	Palazzo Reale, Milan. *Alberto Giacometti: Sculture, dipinti, disegni*, 26 January – 2 April 1995.
NORWICH 1996	Sainsbury Centre for Visual Arts, University of East Anglia. *Trapping Appearance, Portraits by Francis Bacon and Alberto Giacometti from the Robert and Lisa Sainsbury Collection*, 25 June – 15 September 1996
VIENNA 1996	Kunsthalle, Vienna. *Alberto Giacometti 1901–1966*, 24 February – 5 May 1996. Schirn Kunsthalle, Frankfurt.

FRANKFURT 1998 *Alberto Giacometti, 1901–1966: Skulpturen, Gemälde, Zeichnungen und Druckgrafik,* 6 October 1998 – 3 January 1999.

BOLOGNA 1999 Museo Morandi, Bologna. *Alberto Giacometti: Disegni, sculture e opere grafiche,* 25 June – 6 September 1999.

PARIS 2001 Musée national d'art moderne, Paris. *Alberto Giacometti: Le dessin à l'oeuvre,* 24 January – 9 April 2001.

ZÜRICH 2001 Kunsthaus, Zürich. *Alberto Giacometti,* 18 May – 2 September 2001.

PHOTOGRAPHIC ACKNOWLEDGEMENTS

Paul Almasy/Schweizerische Stiftung für die Photographie: page ii; James Austin: Figs. 3, 4, 5, 11, 12, Cat. nos. 1, 3, 6, 7, 9, 10a, 10b, 12, 13, 17, 18, 23, 24, 25, 26, 29, 31, 32, 34, 37, 43, 44, 53, 54, 55, 56, 57, 58, 59, 60, 73, 82, 96, 103; Christian Baur, Basel: Cat. nos. 15, 20, 40 Henri Cartier-Bresson/Schweizerische Stiftung für die Photographie: p. 148; Centre Pompidou – MNAM-CCI, Paris. CNAC/MNAM Dist RMN: Cat. nos. 46; Cooper, London: Cat. nos. 74; The Detroit Institute of Arts: Cat. nos. 72, 80; The Fitzwilliam Museum, Cambridge: Cat. no 5; Foundation Maeght: Cat. nos. 48, 65; Galerie Maeght, Paris: Cat. nos. 11, 21, 38, 67, 68, 69, 71, 75, 77, 84, 85, 86, 87, 88, 94; Galerie Pieter Coray: Cat. nos. 30, 39, 47, 52, 89; Claude Germain: Cat. nos. 36, 64; Alberto Giacometti Stiftung, Kunst Museum Basel: Cat. no 41; Annette Giacometti Estate: Cat. nos. 4, 14, 27, 45, 99, 101, 104, 105, 106; Kunsthaus, Zürich: Cat. nos. 8, 19; Alexander Liberman/Schweizerische Stiftung für die Photographie: Fig. 6; Claude Mercier, Geneva: Fig. 10, Cat. nos. 33, 49, 50, 51, 78, 79, 81, 83, 90, 91, 92, 93, 97; Georges Pierre/Schweizerische Stiftung für die Photographie: Fig. 9; Emile Savitry/Schweizerische Stiftung für Photographie; Peter Schalchi, Zurich: Cat. nos. 28, 35, 61, 63, 76; Ernst Scheidegger/ Schweizerische Stiftung für die Photographie: p. VIII, Figs. 1, 2, 7; Lee Stalsworth: Cat. no. 66; Tate Gallery, London: Fig. 8; Cat. nos. 2, 16, 100; Rodney Todd-White and Son, London: Cat. nos. 62, 70; John Webb, London: Cat. no. 42; Sabine Weiss/Schweizerische Stiftung für die Photographie: page x.

COPYRIGHT ACKNOWLEDGEMENTS